afghanistan
simon norfolk

for catina
'of night, and the light and the half light…'

afghanistan chronotopia

simon norfolk

dewi lewis publishing

chronotopia

European art has long had a fondness for ruin and desolation that has no parallel in other cultures. Since the Renaissance, artists like Claude Lorraine or Caspar David Friedrich have painted destroyed classical palaces and gothic churches, bathed in a fading golden twilight.

These motifs symbolized that the greatest creations of civilisation – the Empires of Rome and Greece or the Catholic Church – even these have no permanence. Eventually, these too would crumble; vanquished by savages and vanishing into the undergrowth. The only thing that could last, that was truly reliable, was God. And man's only rational response in the face of God's power, was awe.

The landscapes of Afghanistan are also 'awesome' (in the original sense of this word) but the feelings of dread and insignificance are not at the power of God but at the power of modern weaponry.

Afghanistan is unique, utterly unlike any other war-ravaged landscape. In Bosnia, Dresden or the Somme for example, the devastation appears to have taken place within one period, inflicted by a small gamut of weaponry.

However, the sheer length of the war in Afghanistan, now in its 24th year, means that the ruins have a bizarre layering; different moments of destruction lying like sedimentary strata on top of each other. A parallel is the story of Heinrich Schliemann's discovery of the remains of the classical city of Troy in the 1870s. Digging down, he found nine cities deposited upon each other, each one in its turn rebuilt upon the rubble of its predecessor and later destroyed.

Afghanistan keeps similar artefacts in what could be a Museum of the Archaeology of War. Abandoned tanks and troop carriers from the Soviet invasion of the 80s litter the countryside like agricultural scrap or they have been used as footings for embankments and bridges, poking from the earth like malevolent fossils. The land has a different appearance where there was fighting in the early 90s. In this instance the tidy, picked-clean skeletons of buildings are separated by smooth, hard earth where de-mining teams have swept the area. In places destroyed in the recent US and British aerial bombardment, the buildings are twisted metal and charred roof timbers (the presence of unexploded bombs deters all but the most destitute scavengers), giving the place a raw, chewed-up appearance.

Mikhail Bakhtin called this kind of landscape a 'chronotope': a place that allows movement through space and time simultaneously, a place that displays the 'layeredness' of time. The chronotopia of Afghanistan is like a mirror, shattered and thrown into the mud of the past; the shards are glittering fragments, echoing previous civilizations and lost greatness. Here there is a modern concrete teahouse resembling Stonehenge; an FM radio mast like an English maypole; the Pyramids at Giza; the astronomical observatory at Jaipur; the Treasury at Petra; even the votive rock paintings in the caves at Lascaux.

Throughout history, many civilisations have been brought down by barbarians, but the destruction, no matter how savage, always leaves behind a trail of clues. A building destroyed by the cataclysm of an American 15,000 lb bomb creates a different historical record to a structure gradually reduced to its concrete 'bones' by thousands and thousands of small Kalashnikov bullets. The notion of a chronotope is extremely useful here. Art historical references may be intriguing, but the destruction of Afghanistan is first and foremost a human tragedy in which millions lost their lives. The people killed in these attacks leave almost no record – only the forensic traces survive to tell of the carnage. Seeing Afghanistan as a chronotope can reconnect the evidence in the landscape to the story of this human disaster. It points to the archaeological remains that are the only indicators of the appalling suffering that is modern war, a suffering so atrociously suppressed in the mainstream media's coverage.

In a way, I had seen the destruction of Afghanistan before, not directly, but in the Illustrated Children's Bible given to me by my parents when I was a child. When the pictures showed David overcoming Goliath, these Afghan-looking mountains and deserts were the background. If Joshua fought the battle of Jericho, these trees and animals were drawn in the middle distance. More accurately, the landscapes of Afghanistan are how my childish imagination conjured up the Apocalypse or Armageddon. I felt I had already lived these landscapes in the fiery exhortations of a childhood Manchester Sunday School: utter destruction on an epic, Babylonian scale, bathed in the crystal light of a desert sunrise.

Achaemenids, Macedonians, Seleucids, Greco-Bactrians, Indo-Greeks, Mauryans, Parthians, Sacas, Yüeh-Chihs, Kushanians, Sassanians, Hepthalites, Hindu-Shahis, early Muslim Arabs, Abbasids, Tahirids,

kingdoms rising, kingdoms falling,
bowing nations, plumèd wars,
weigh them in an hour of dreaming...

w.b.yeats

Samanids, Saffarids, Ilek Khan Turks, Ghaznavids, Turkish Ghorids, Seljuk Turks, Turkish Khwarazm Shahs, Delhi Sultans, Mongols, Karts, Timurids, Shaybanis, Safavids, Moghuls, Soviets, Americans.

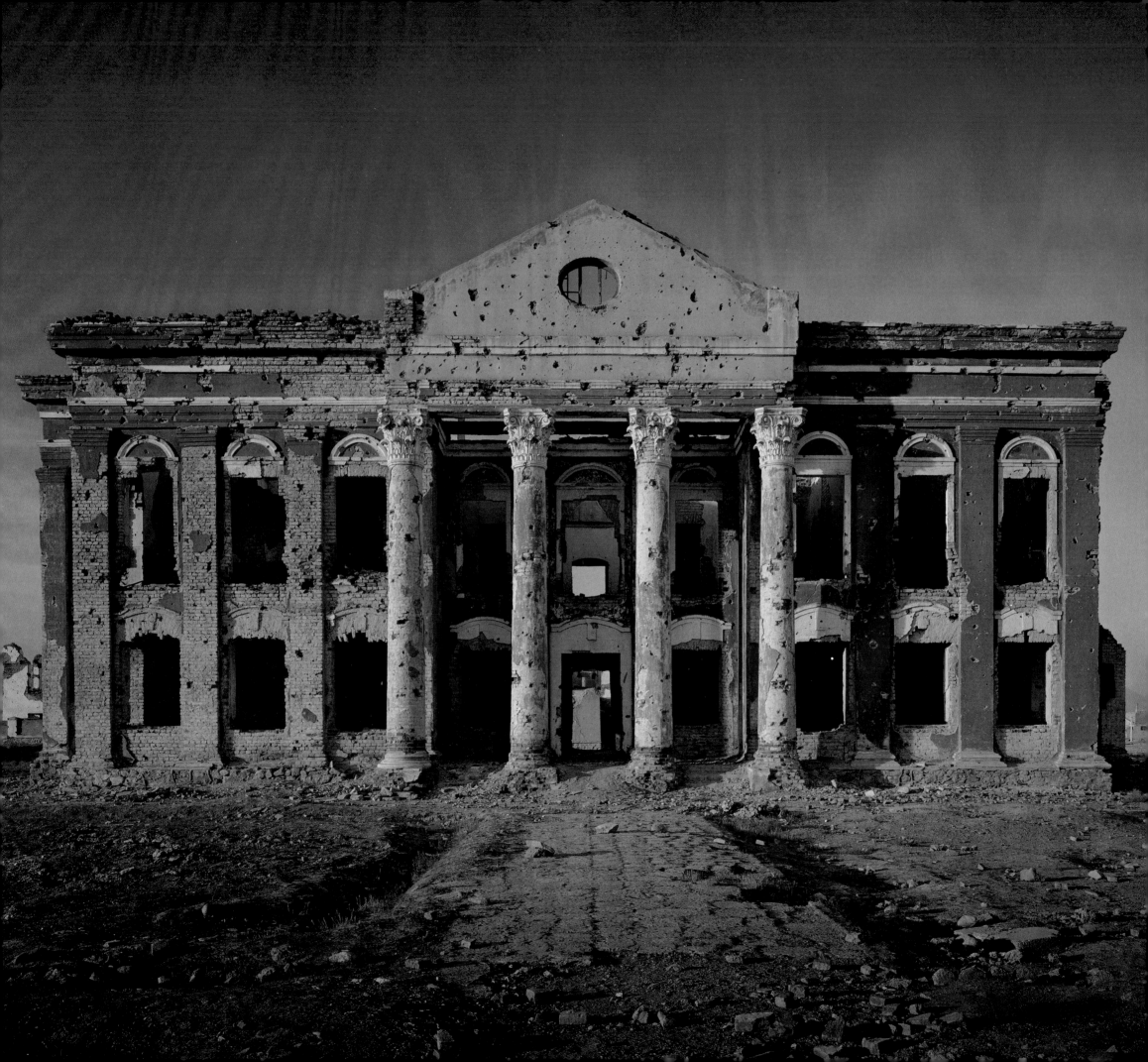

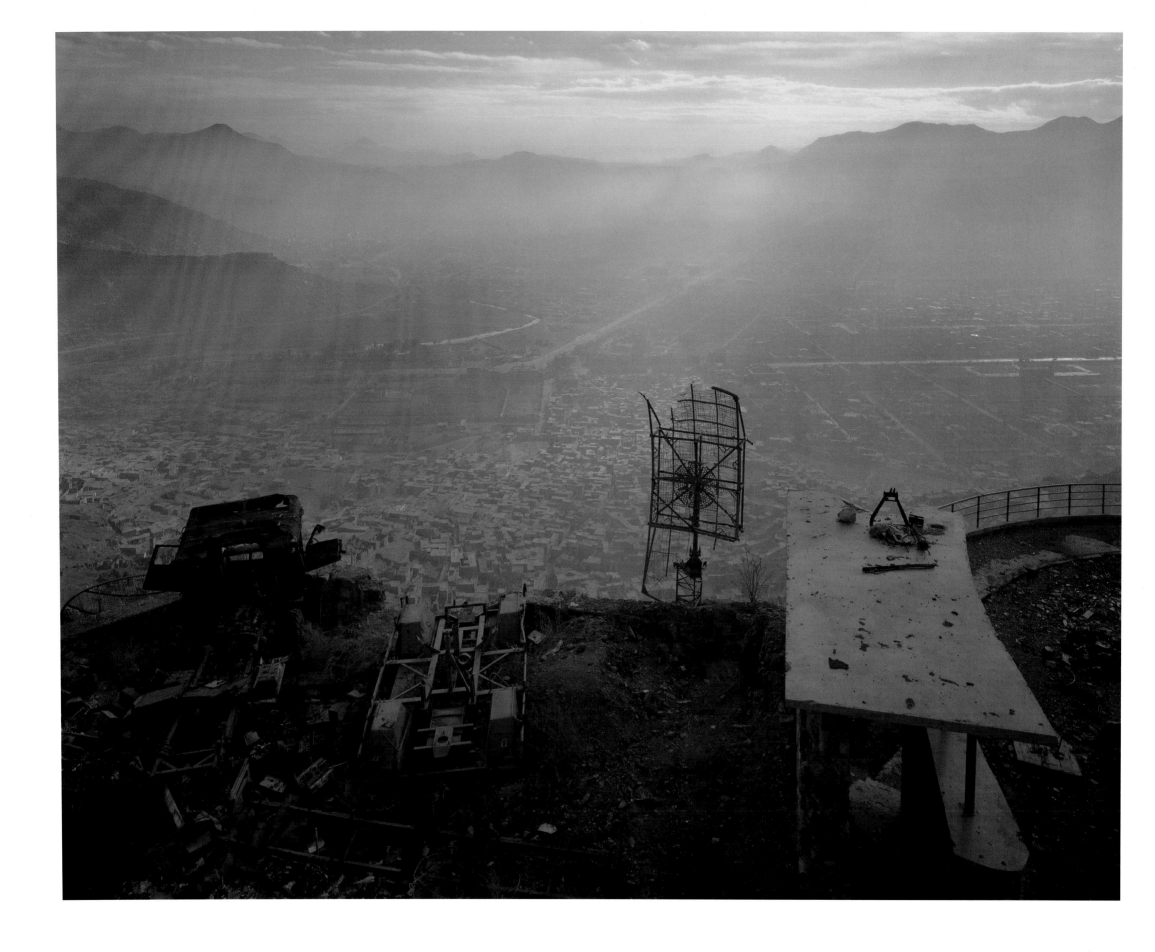

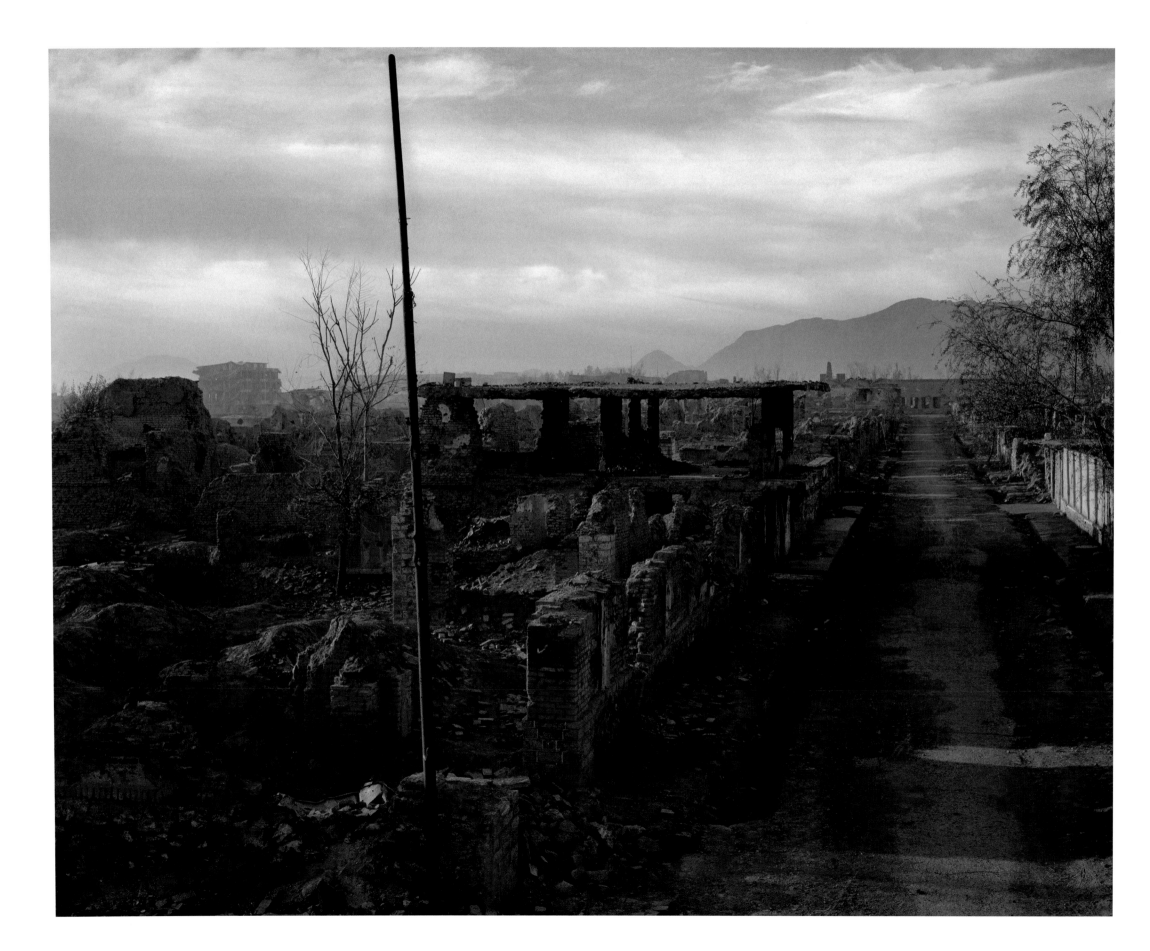

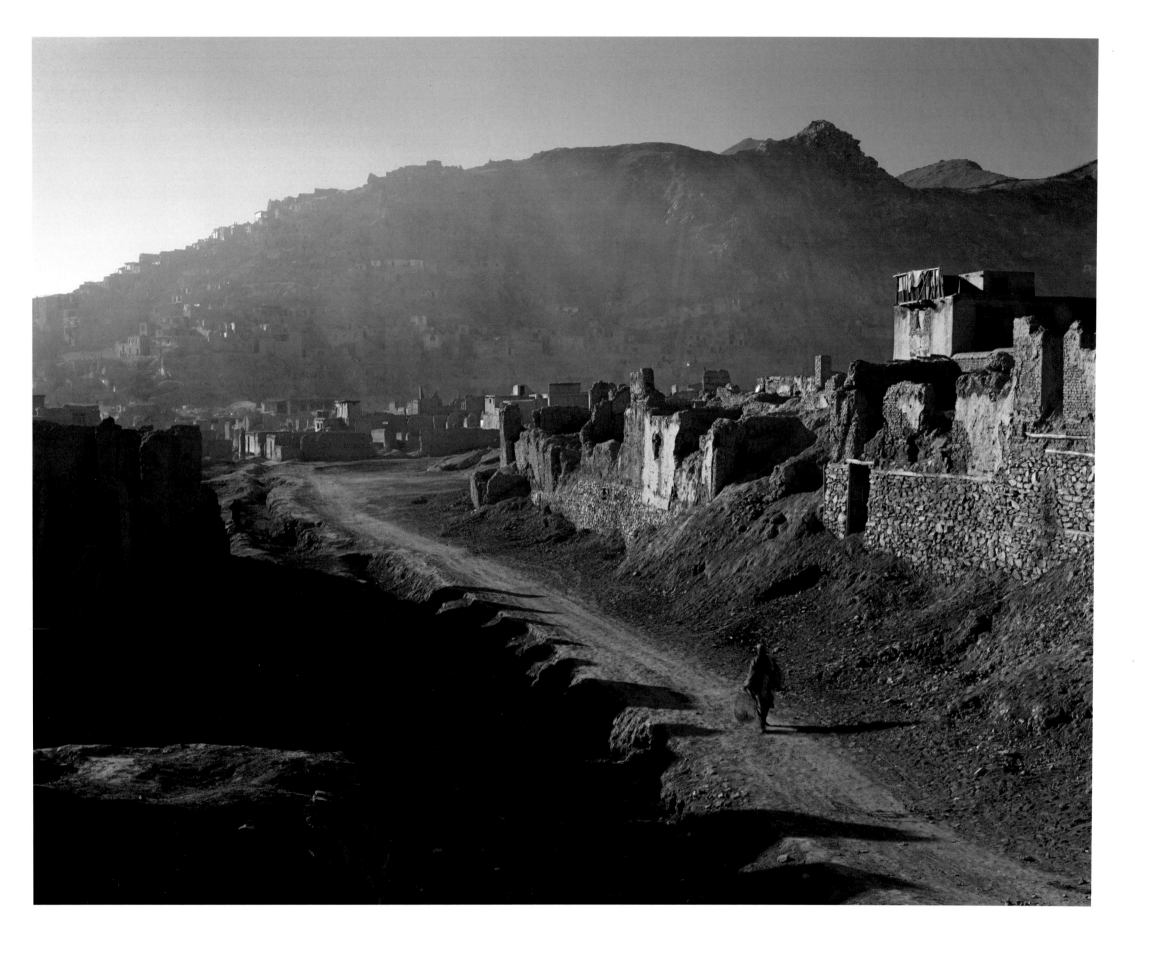

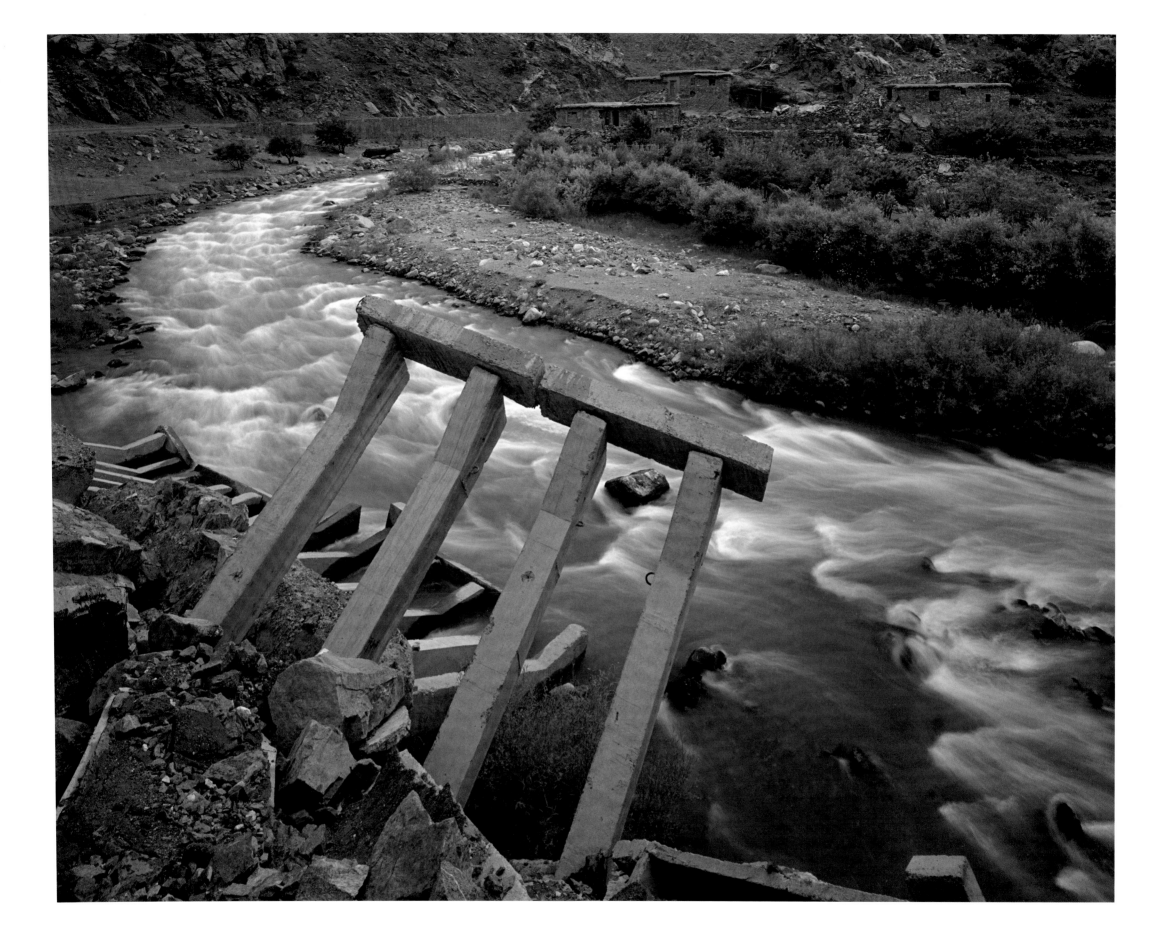

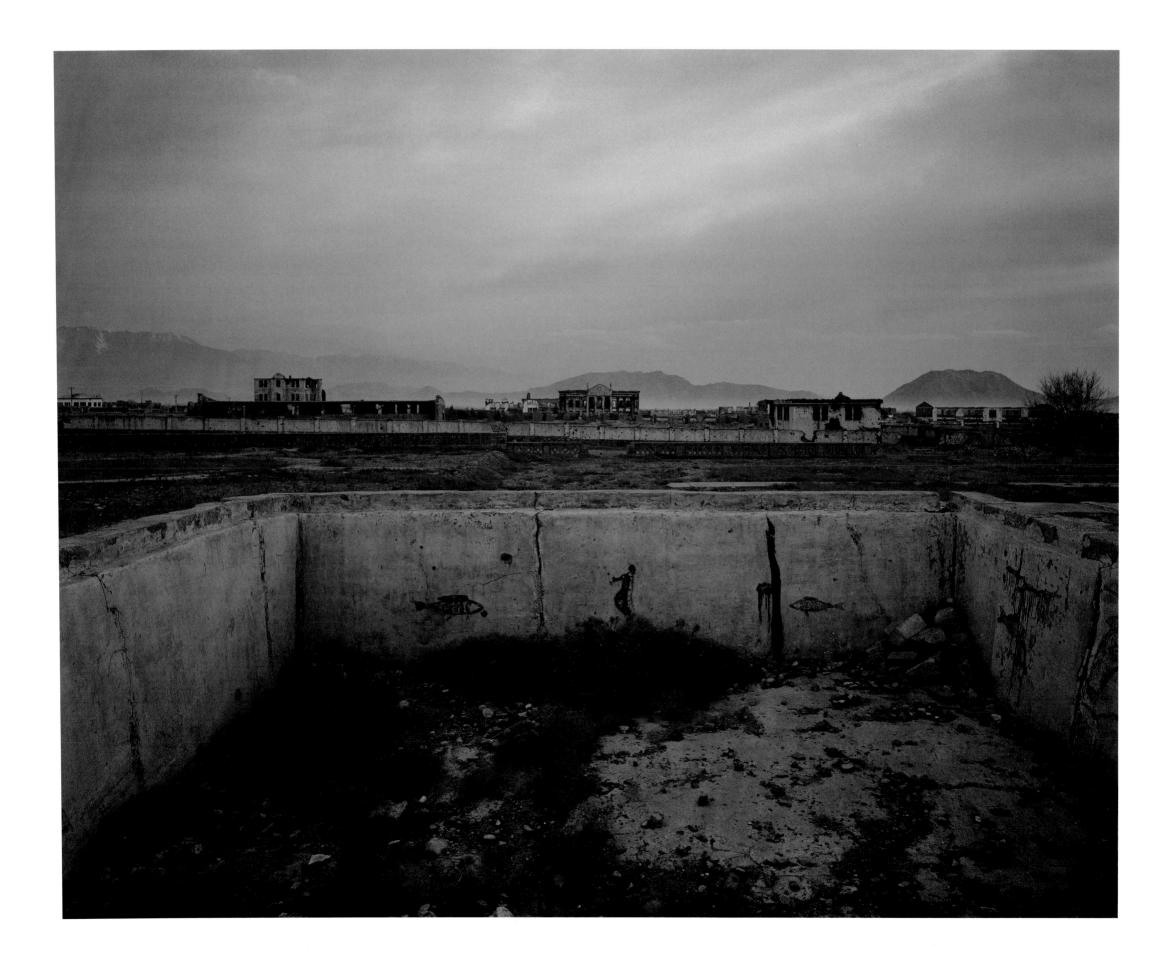

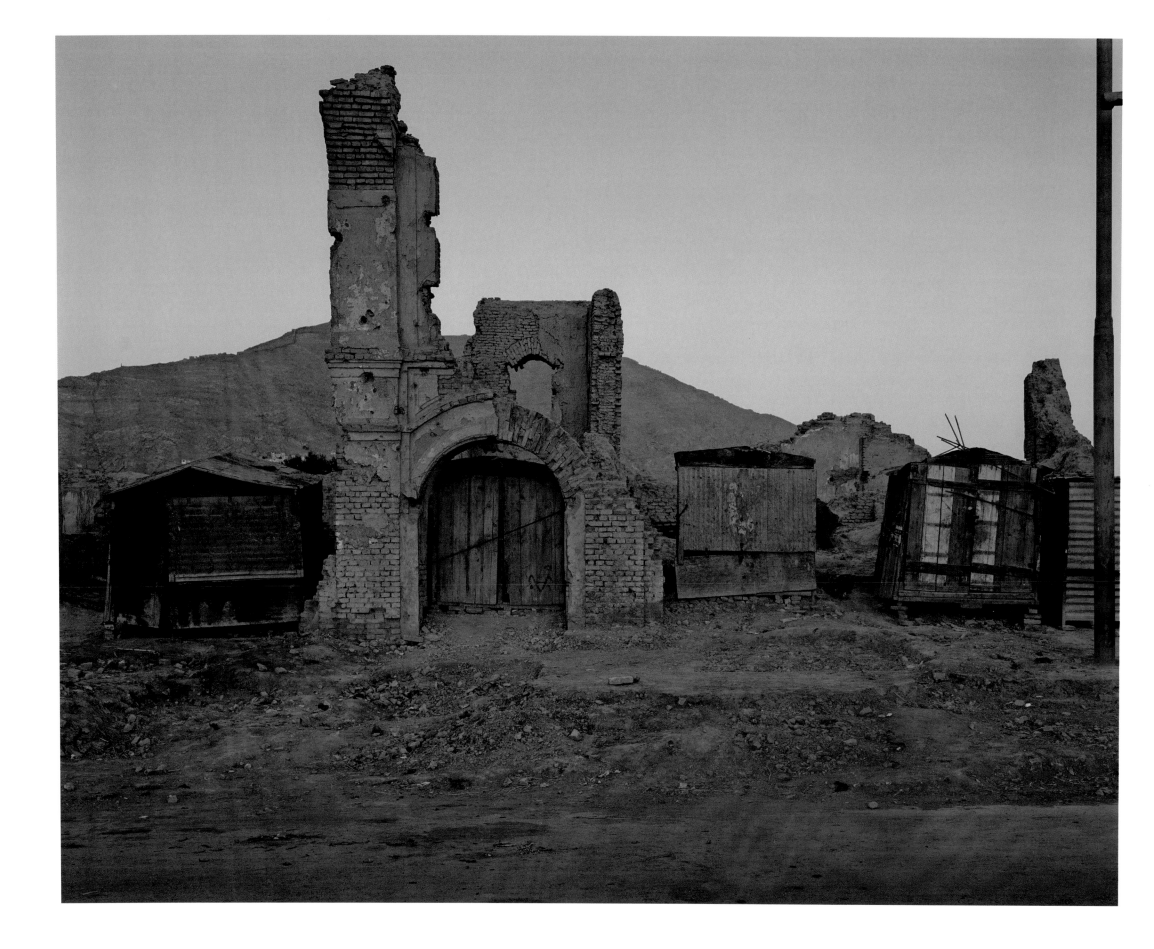

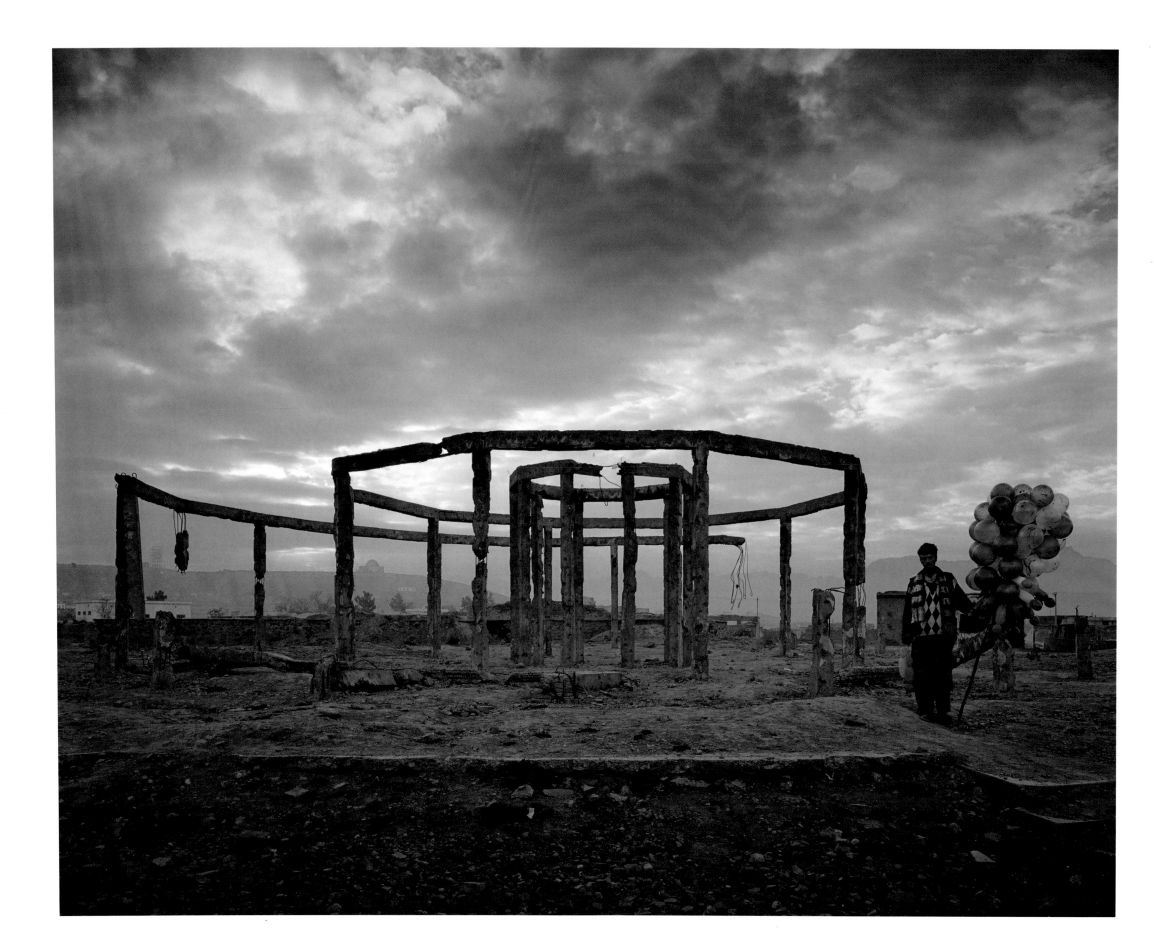

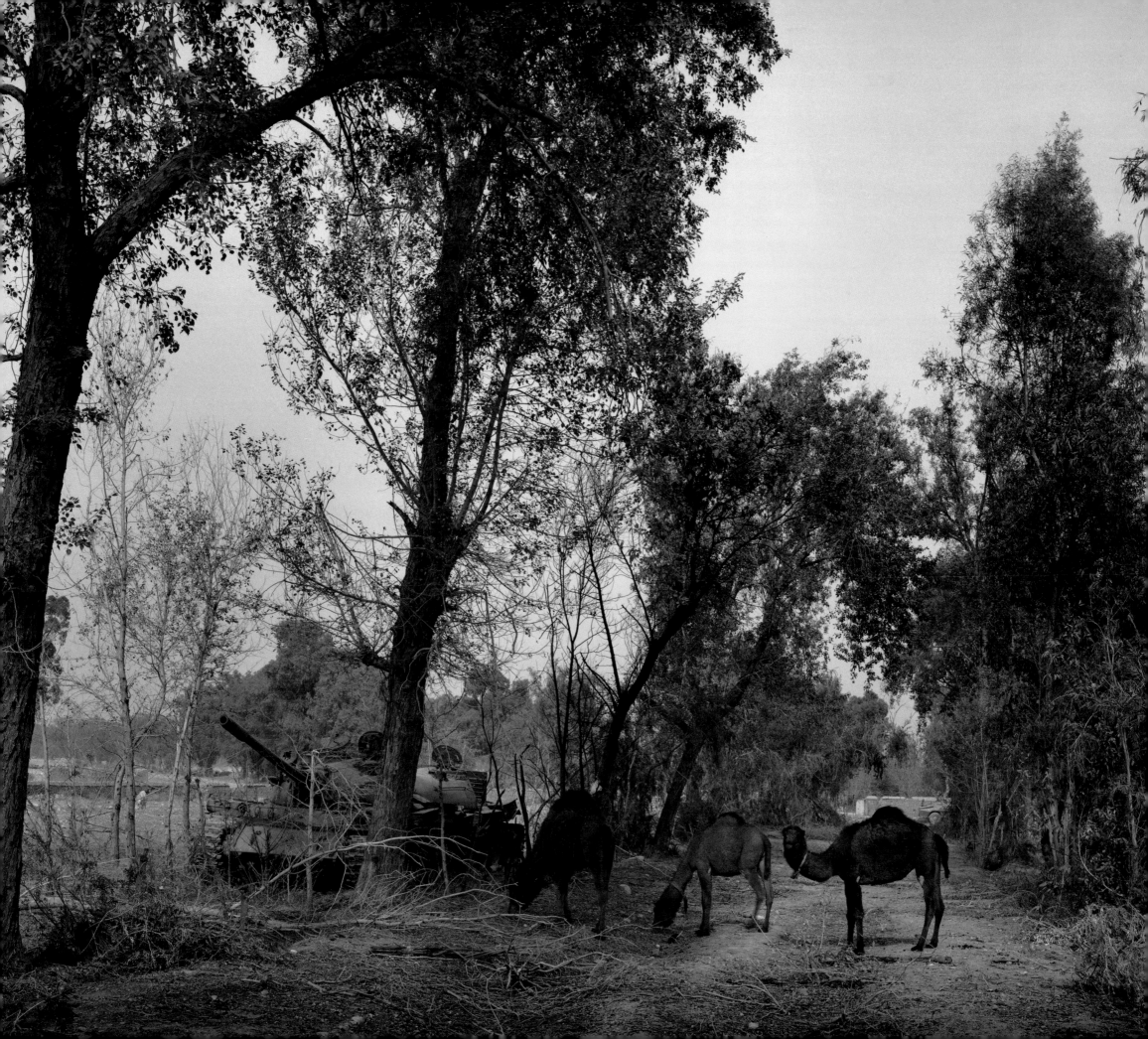

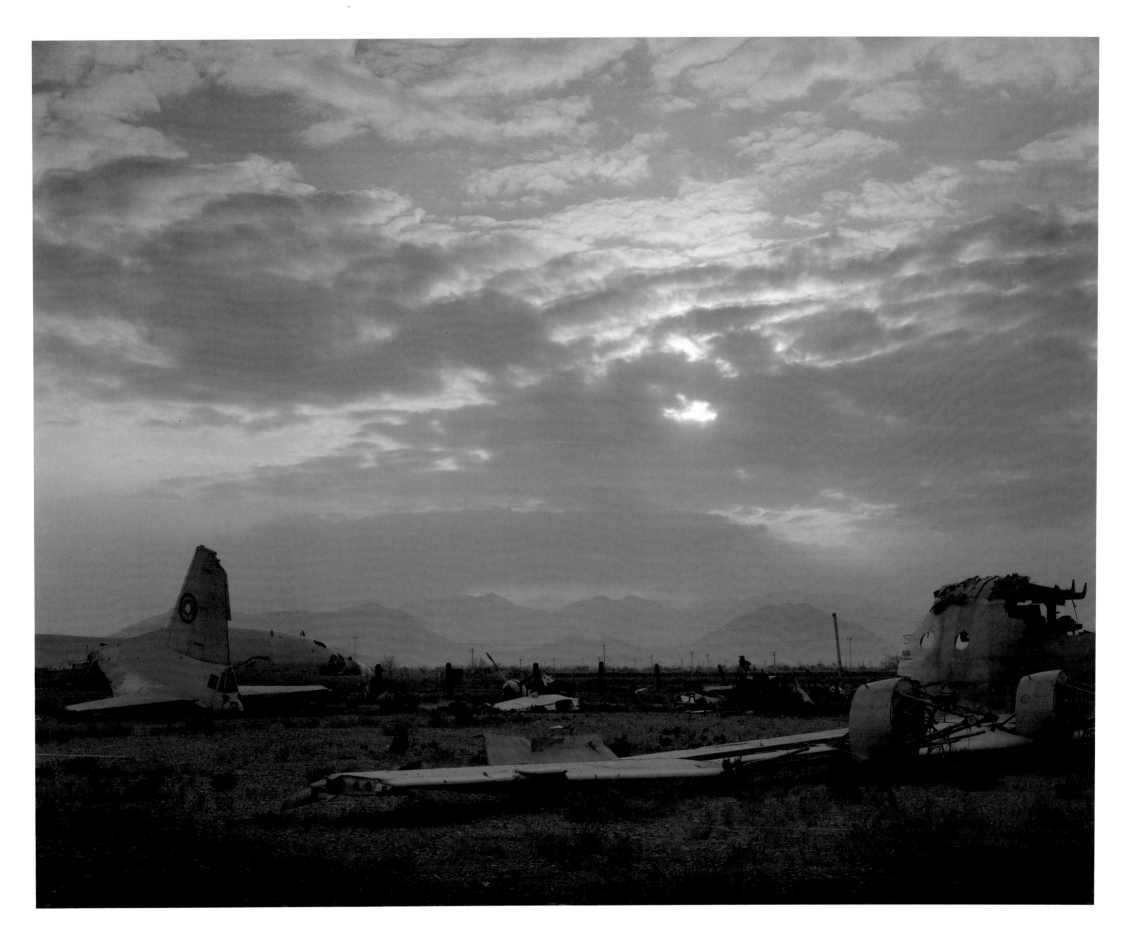

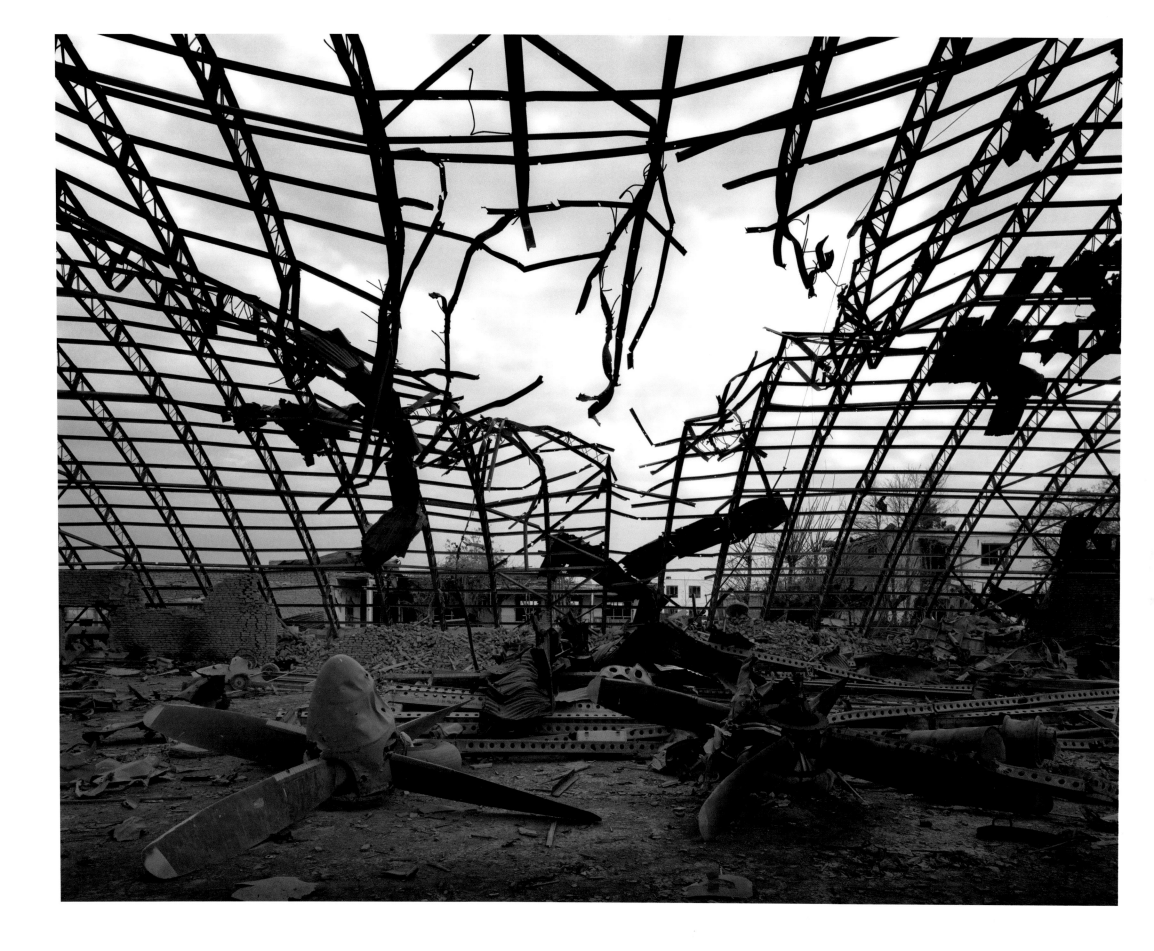

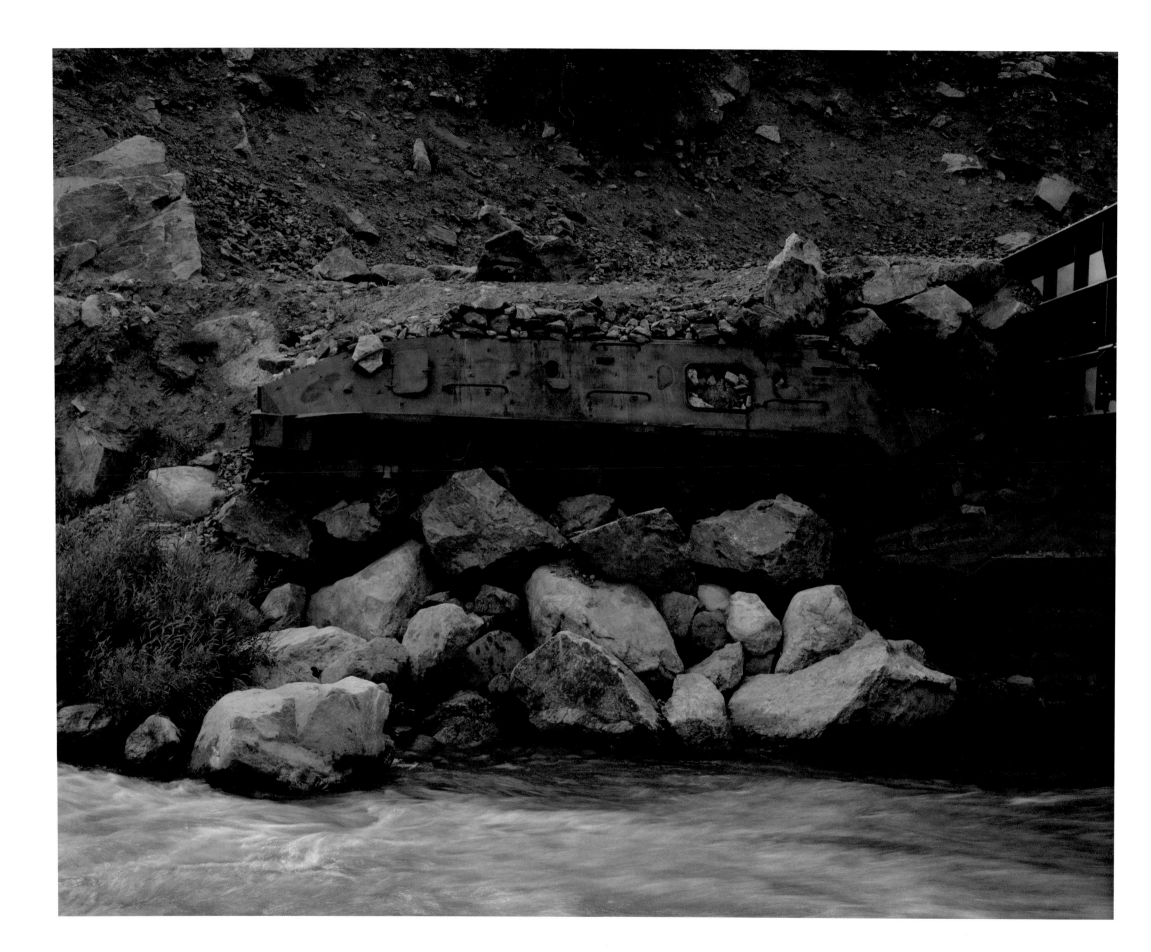

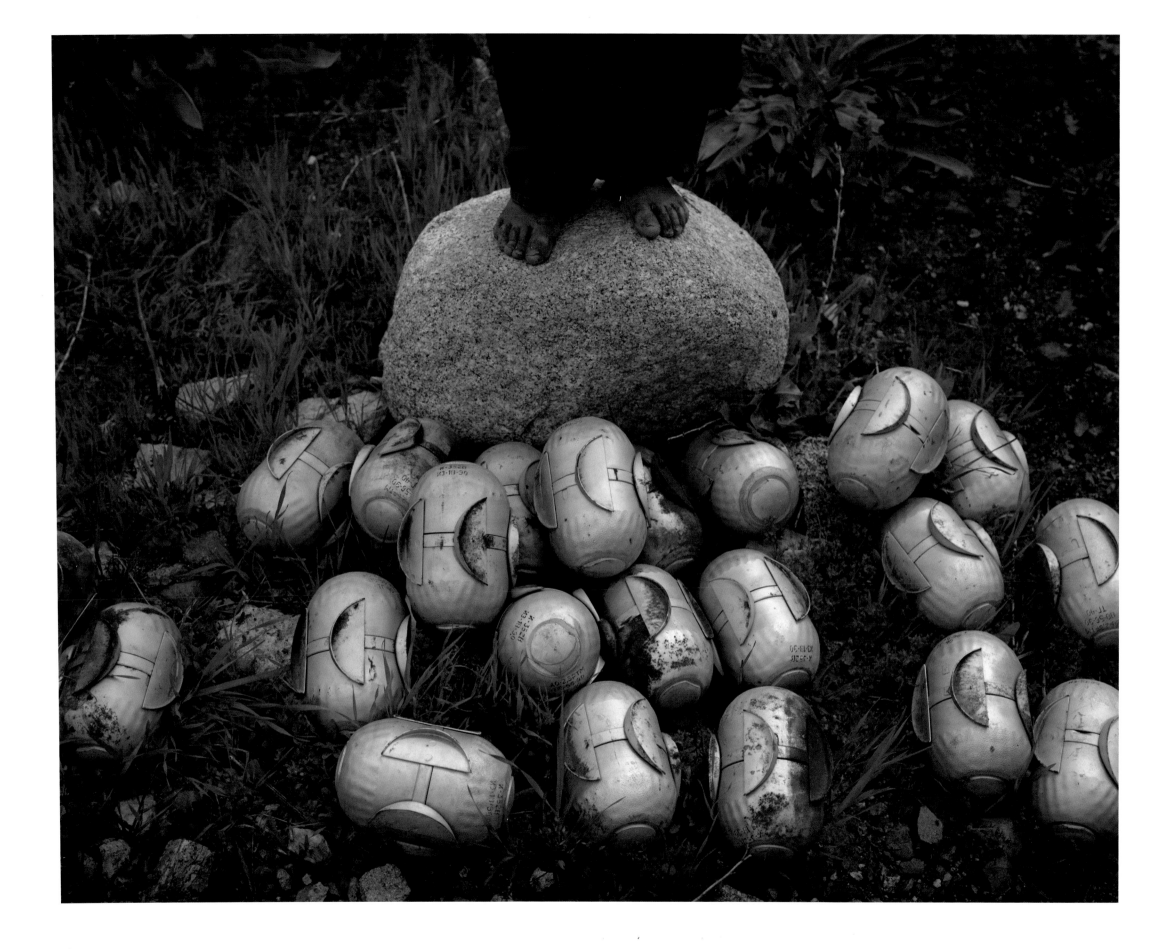

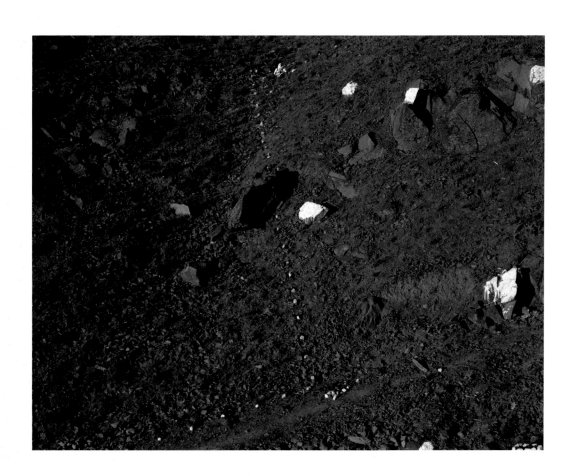

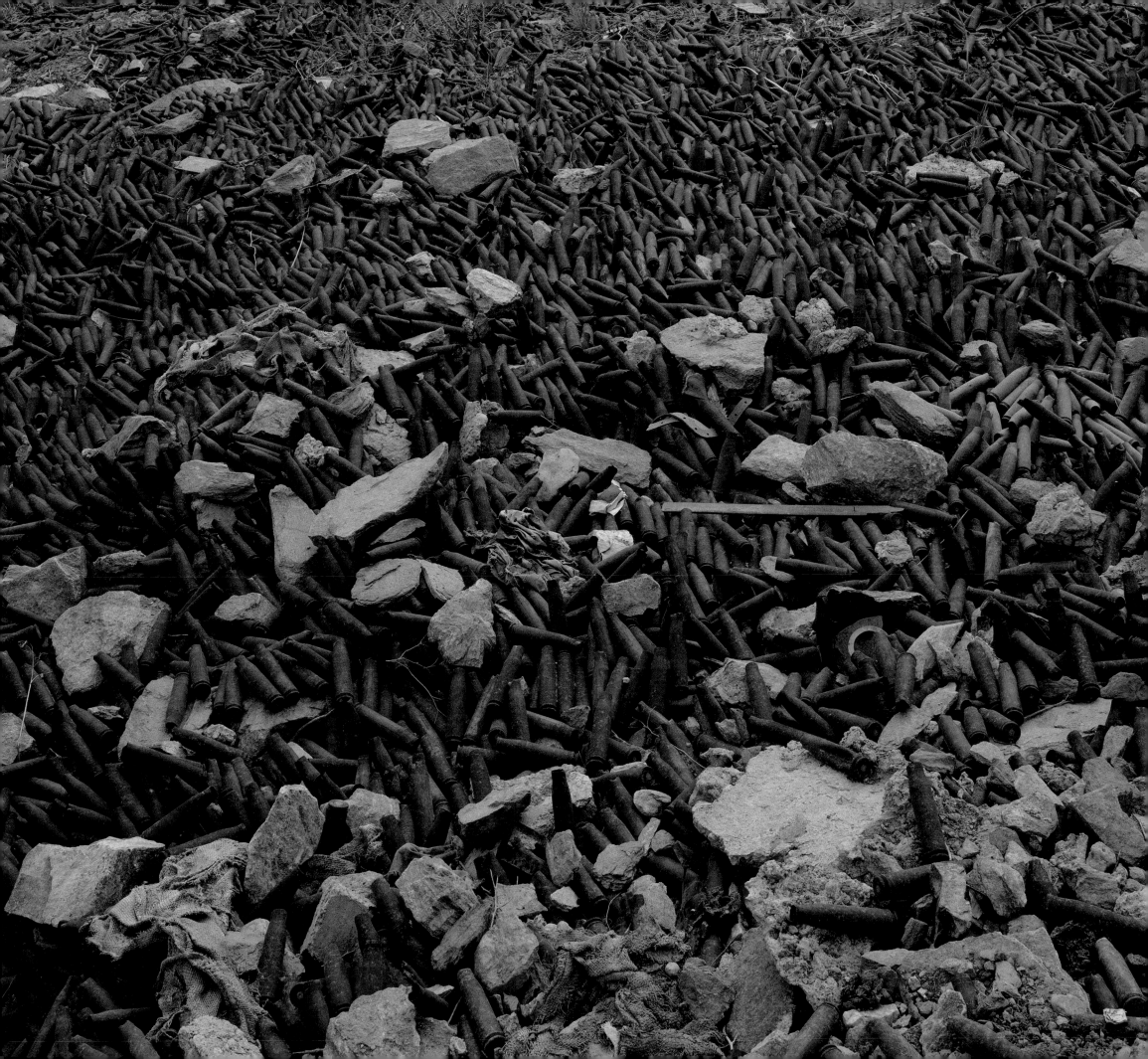

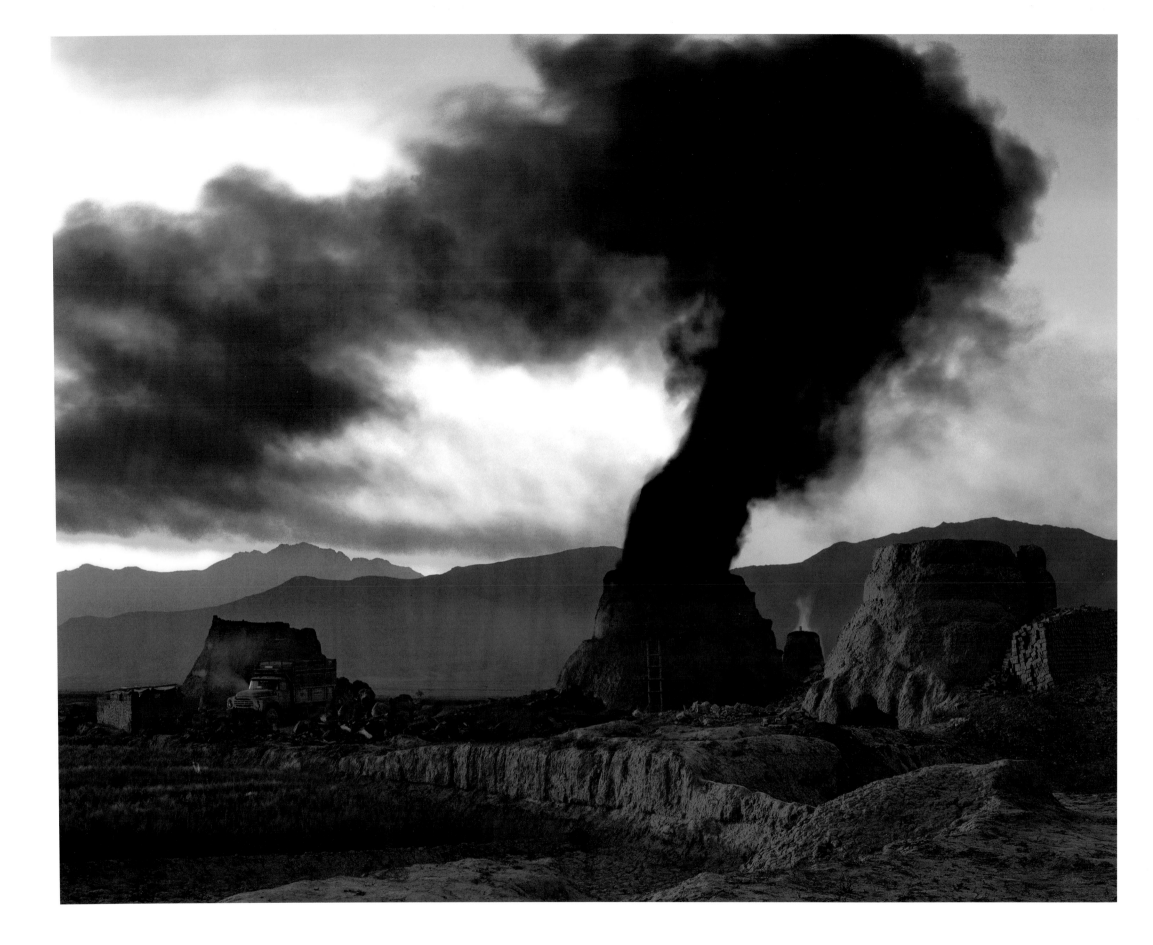

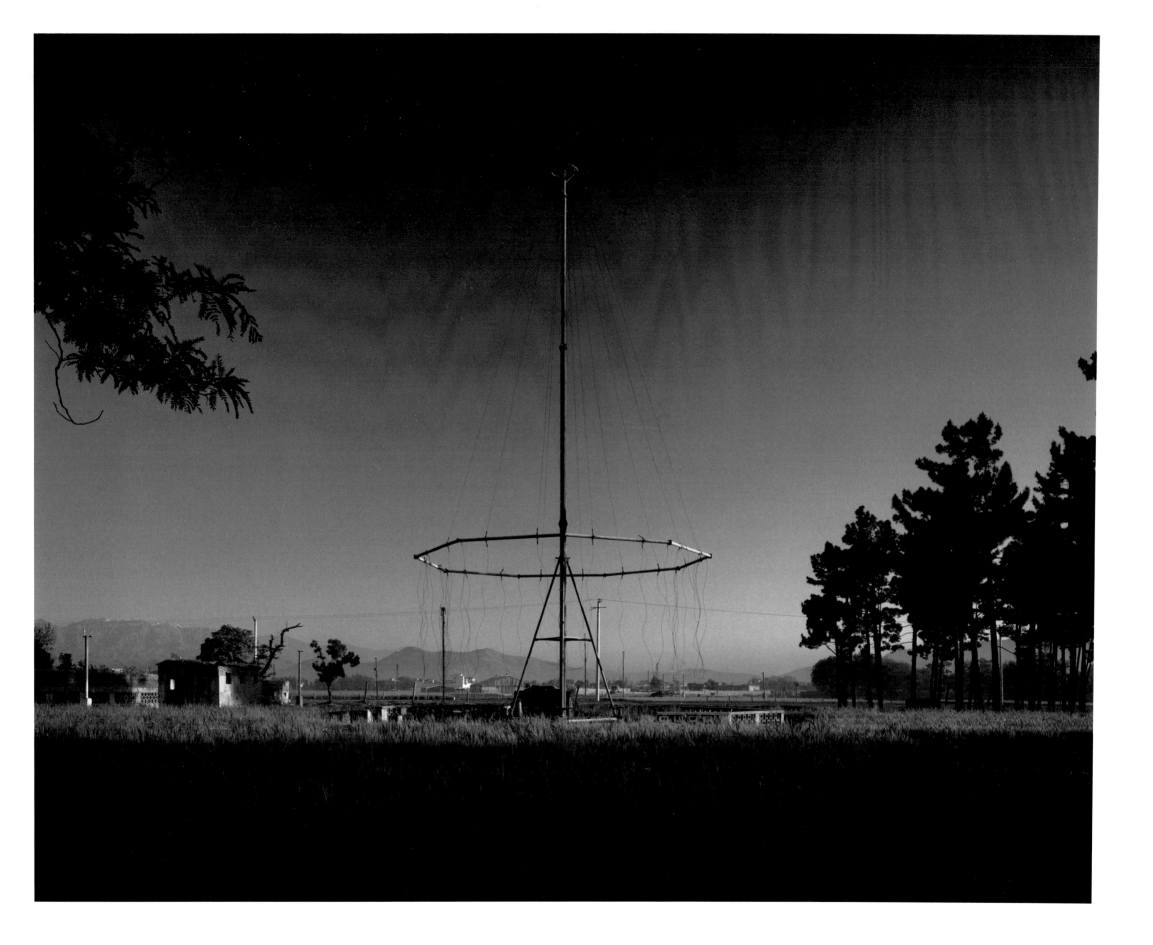

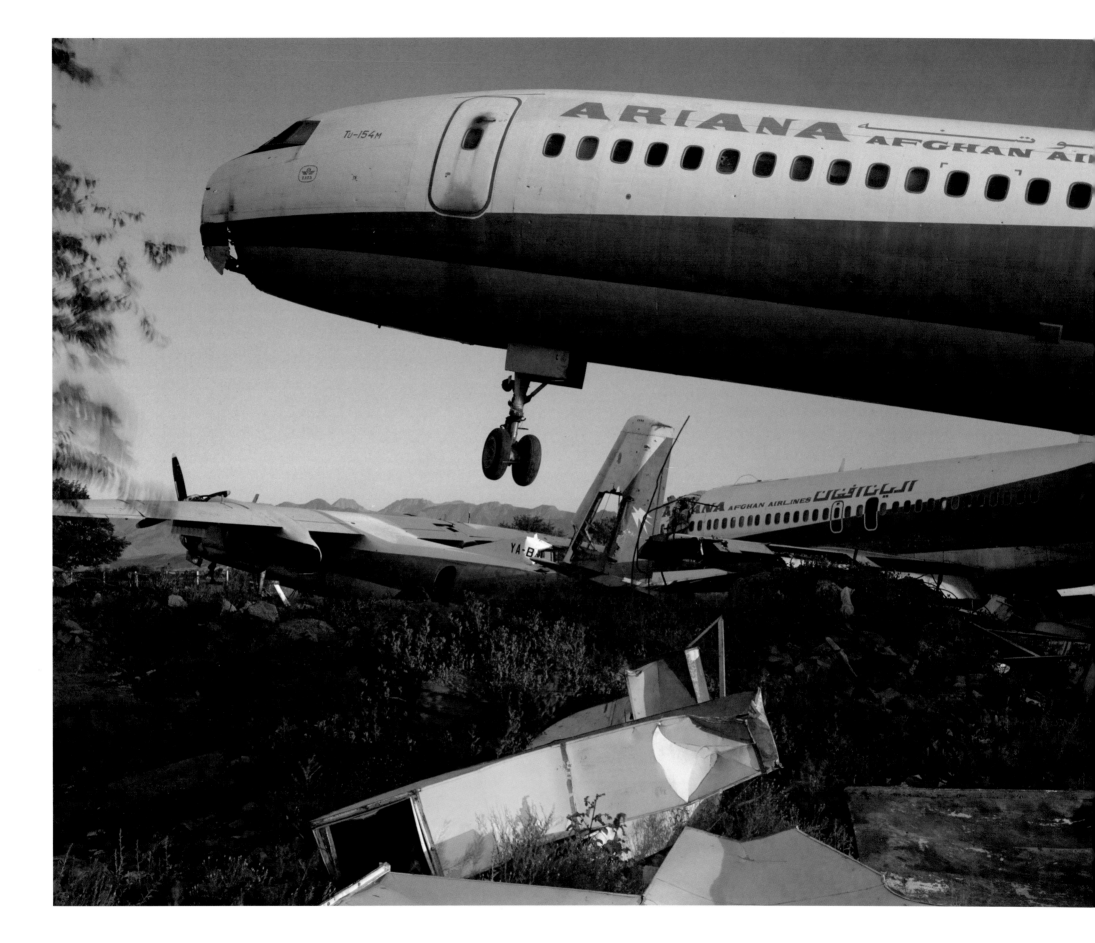

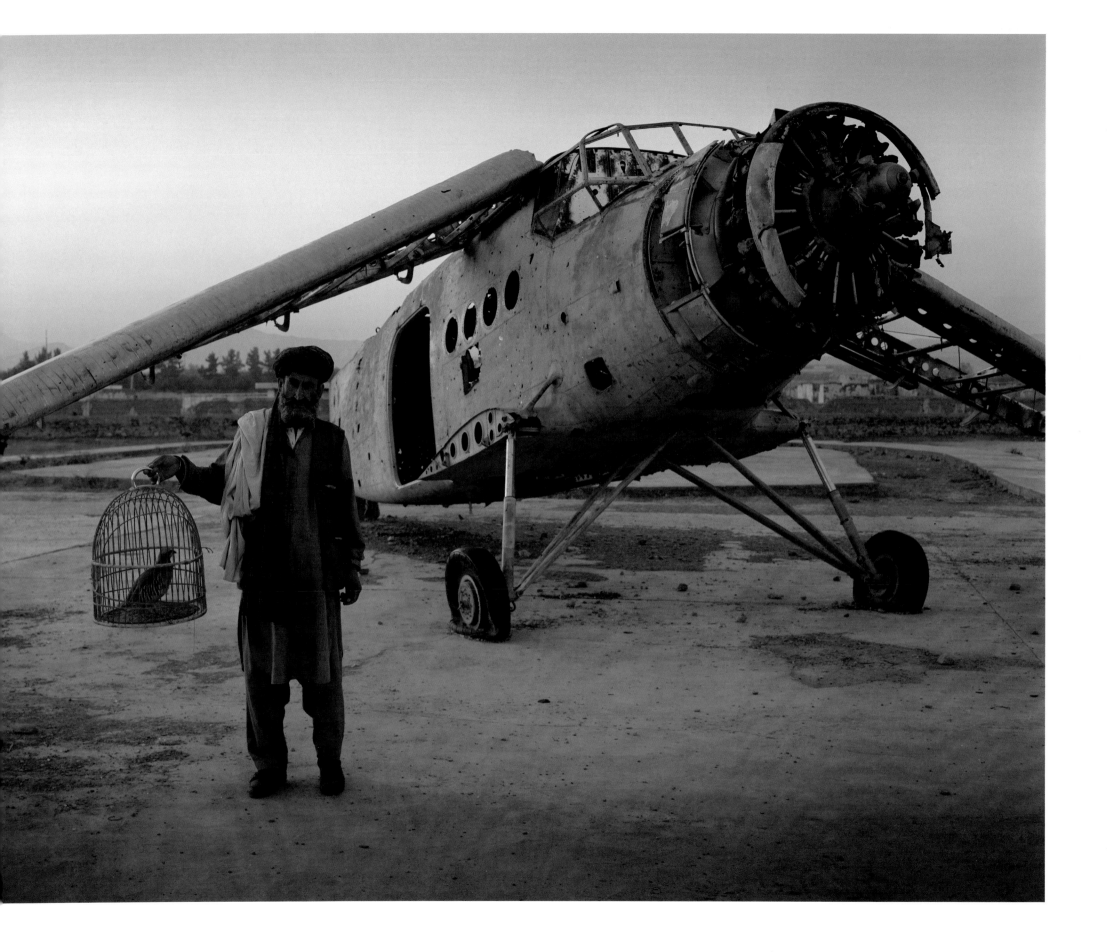

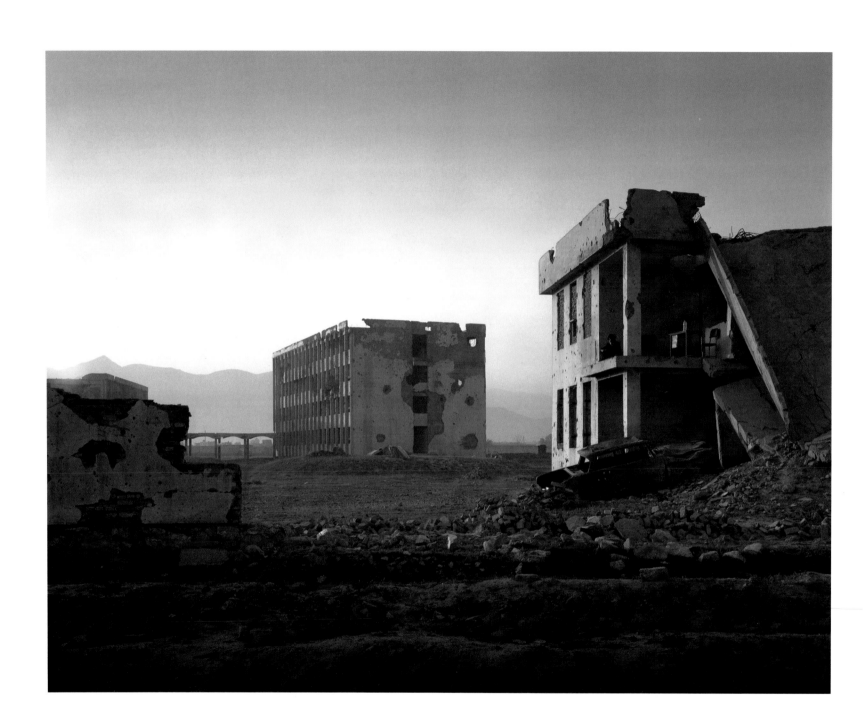

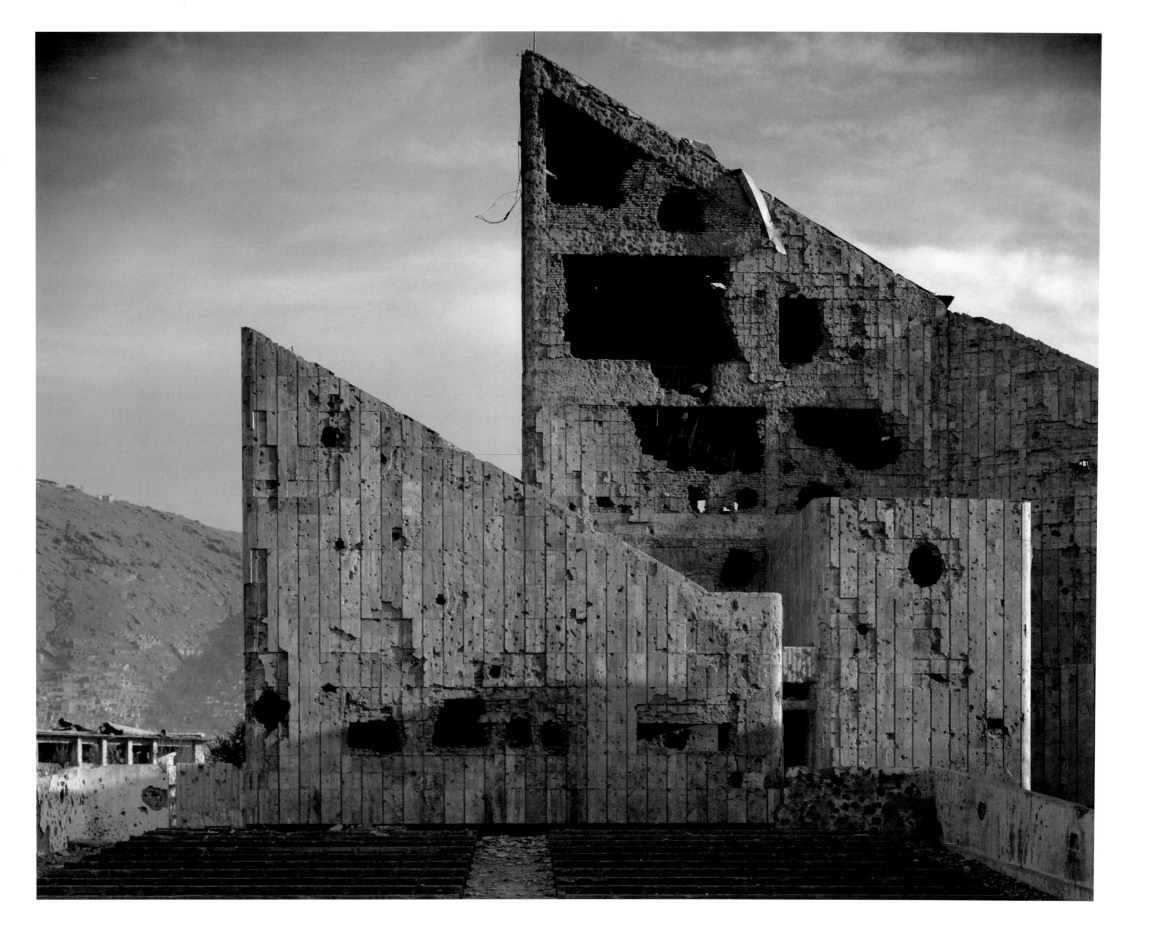

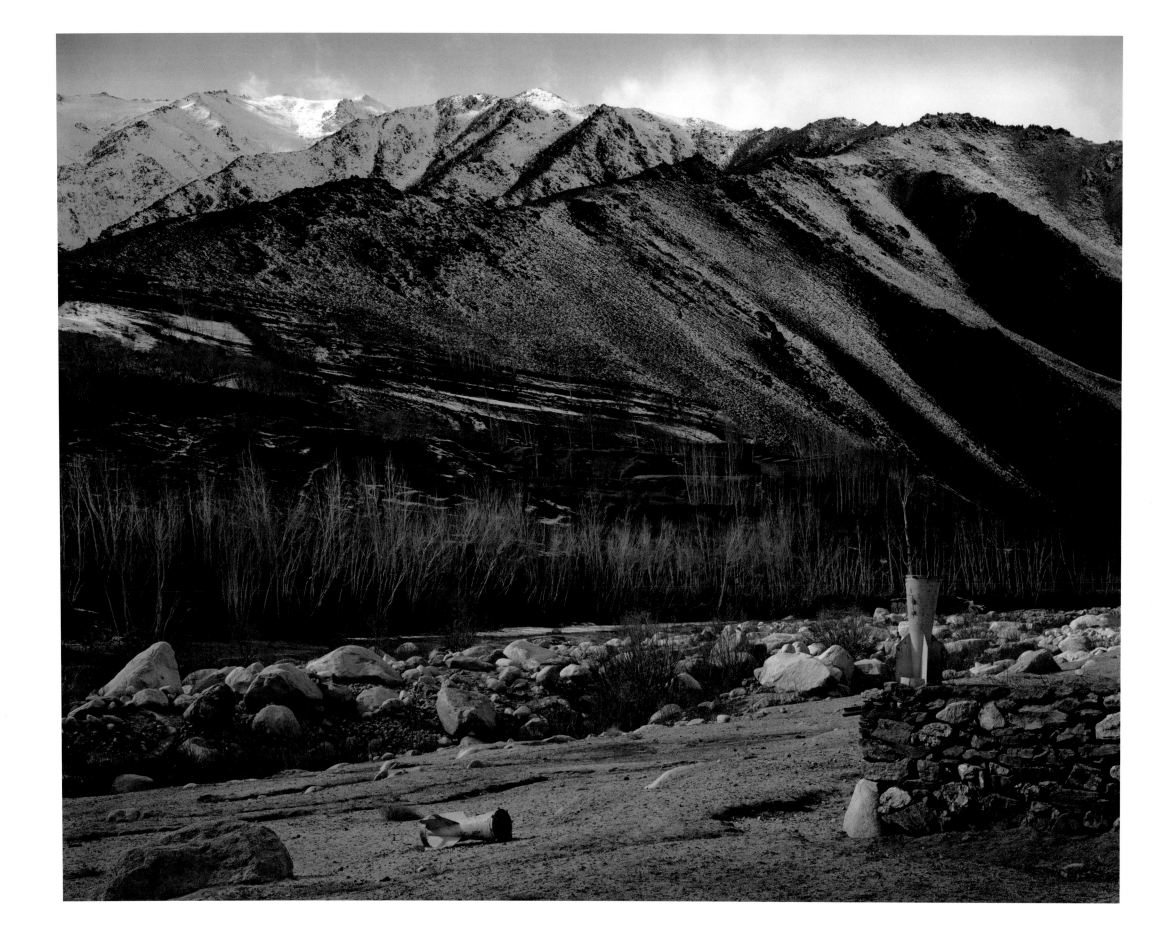

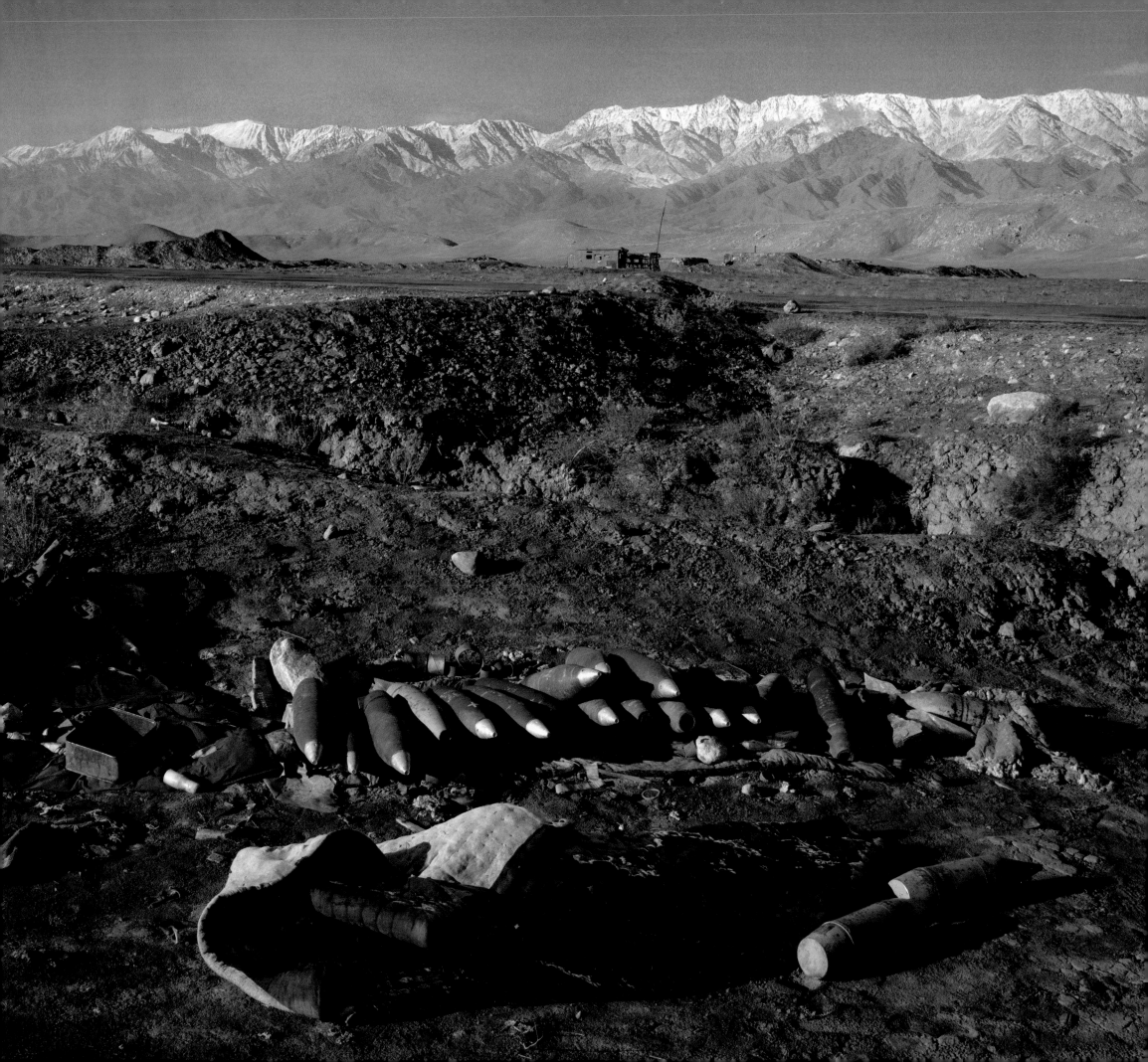

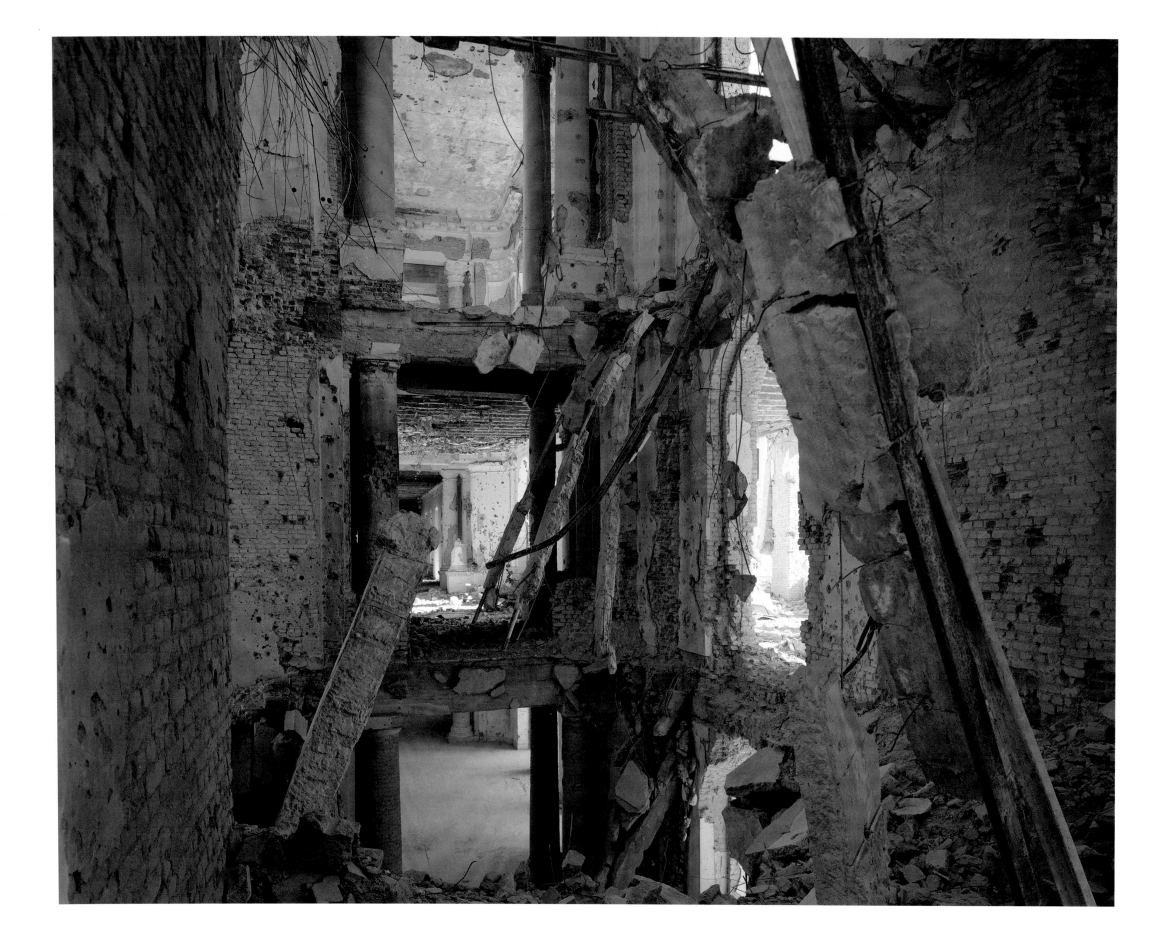

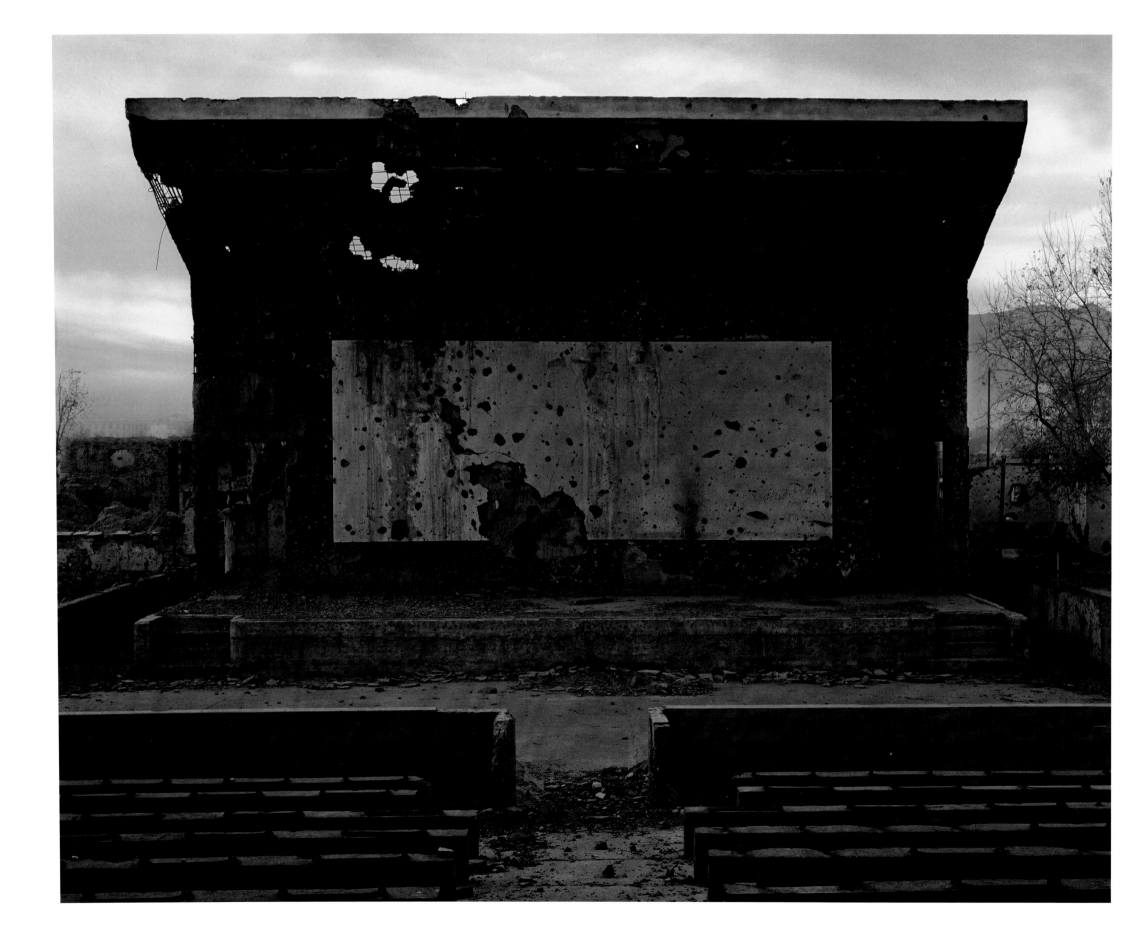

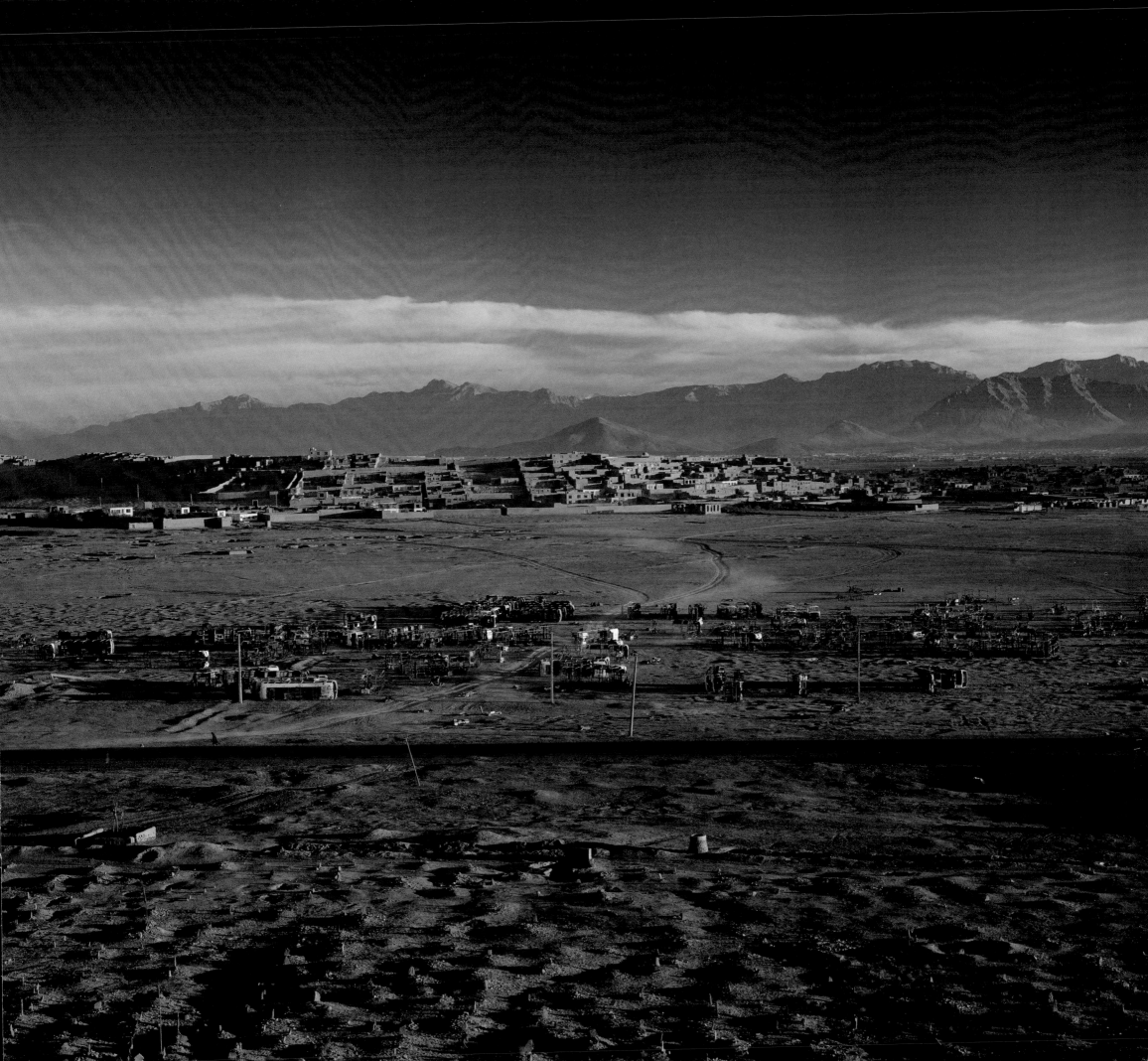

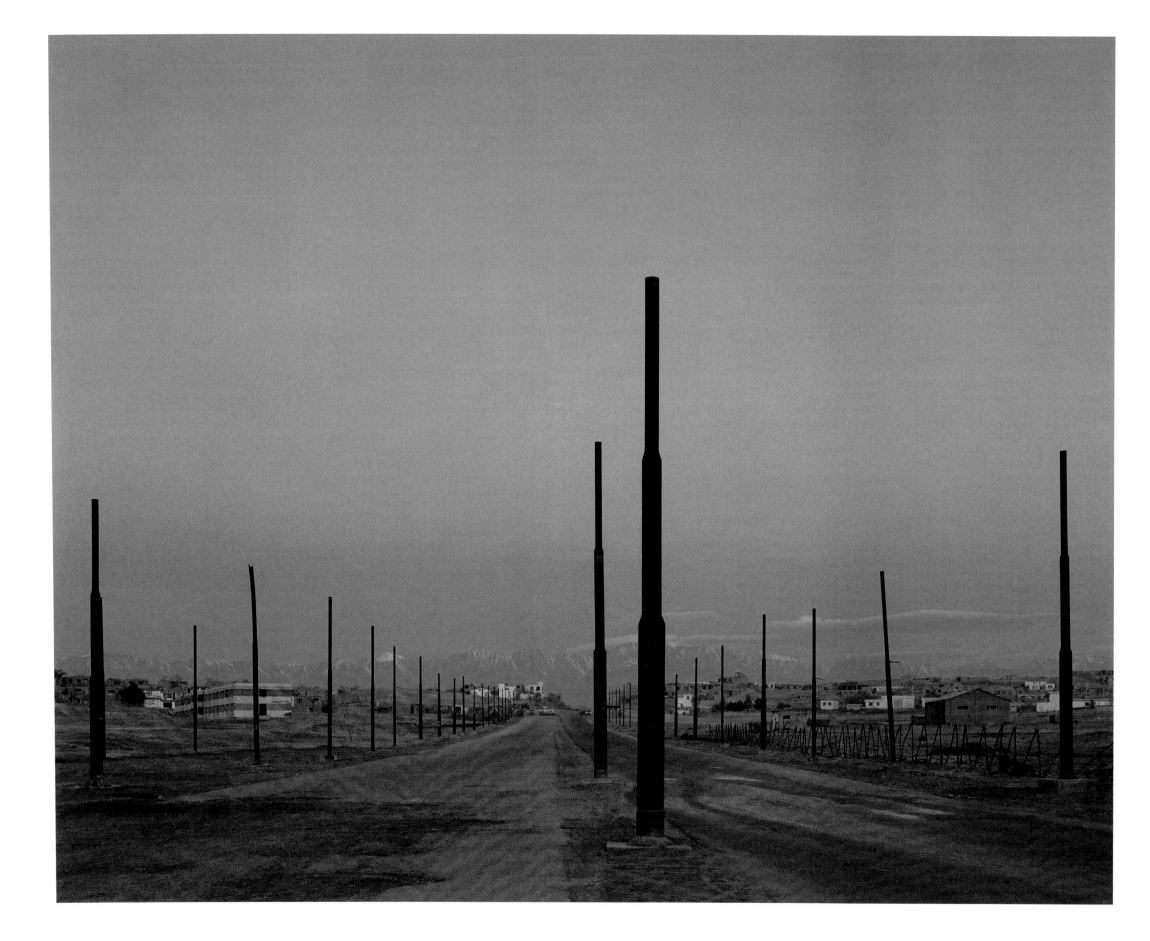

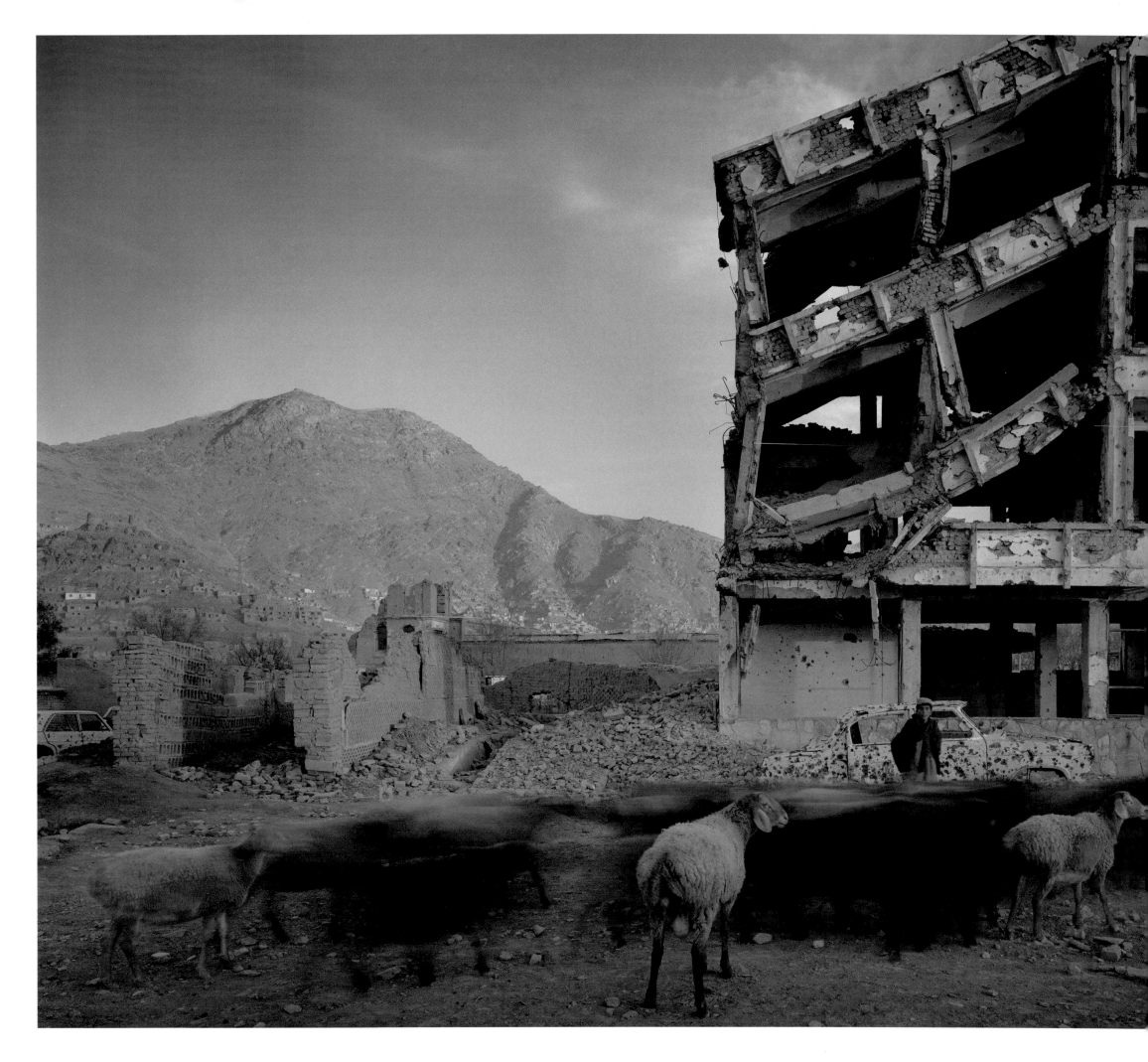

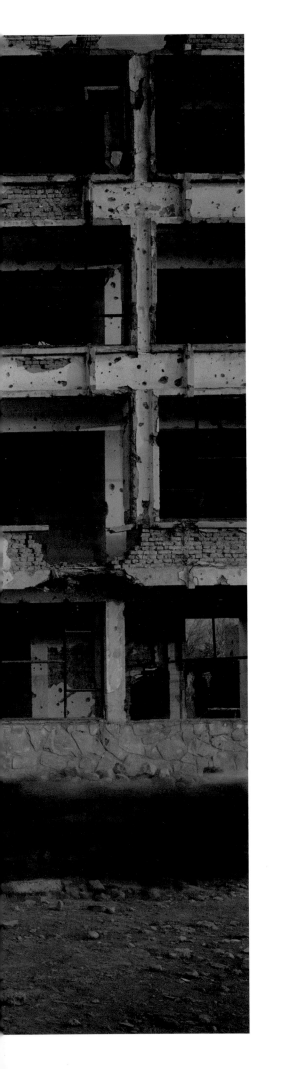

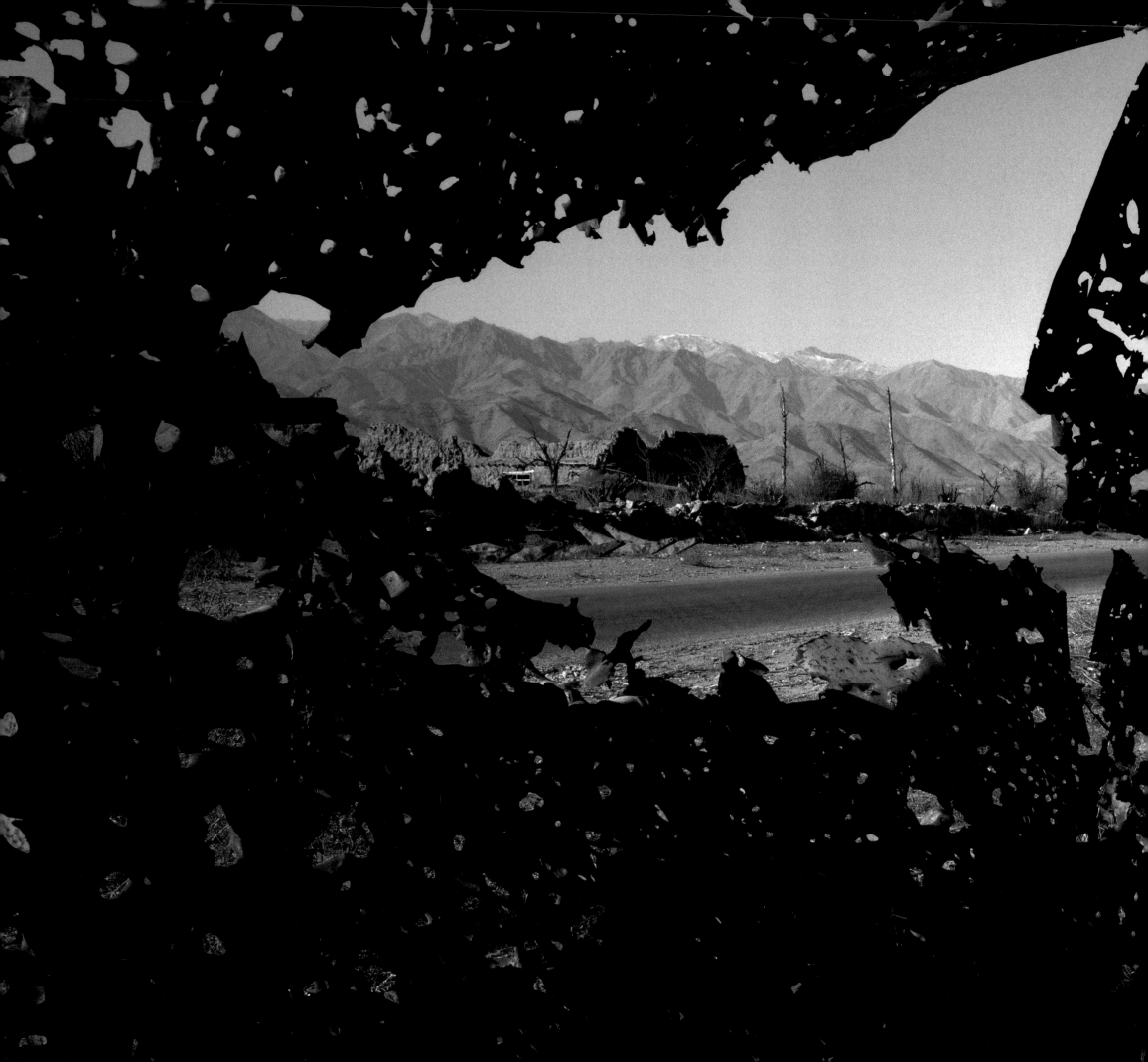

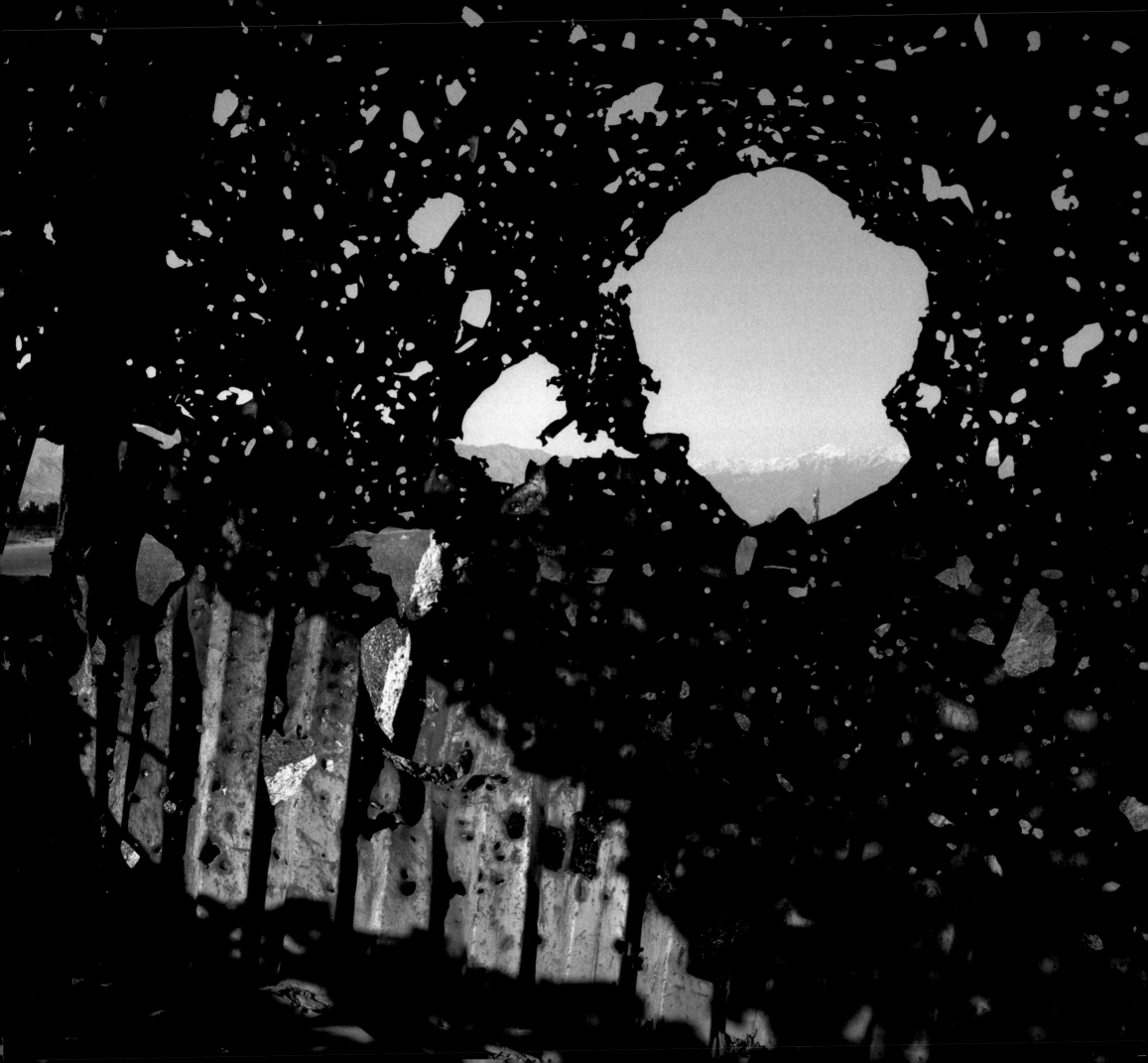

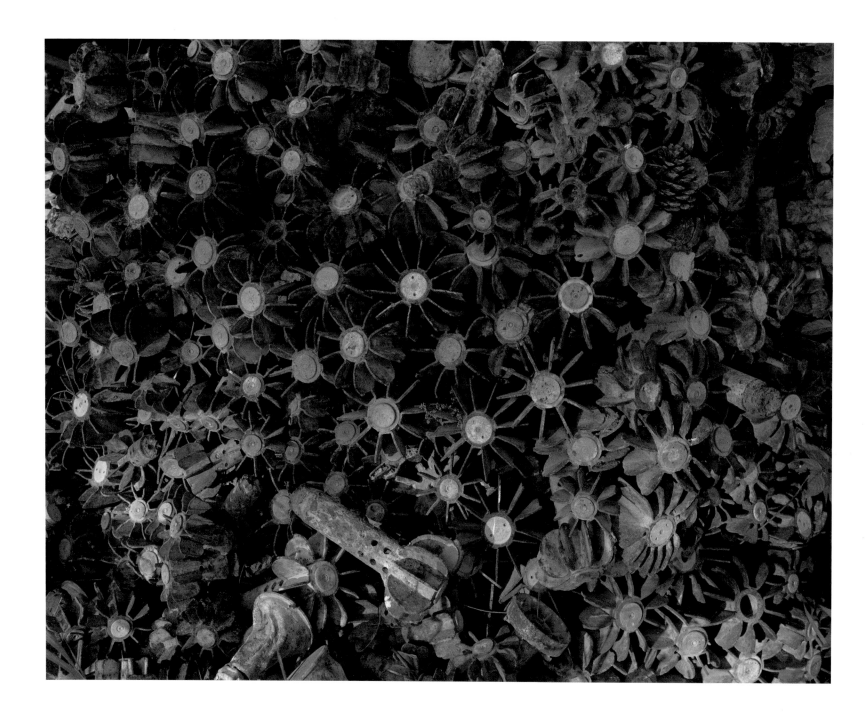

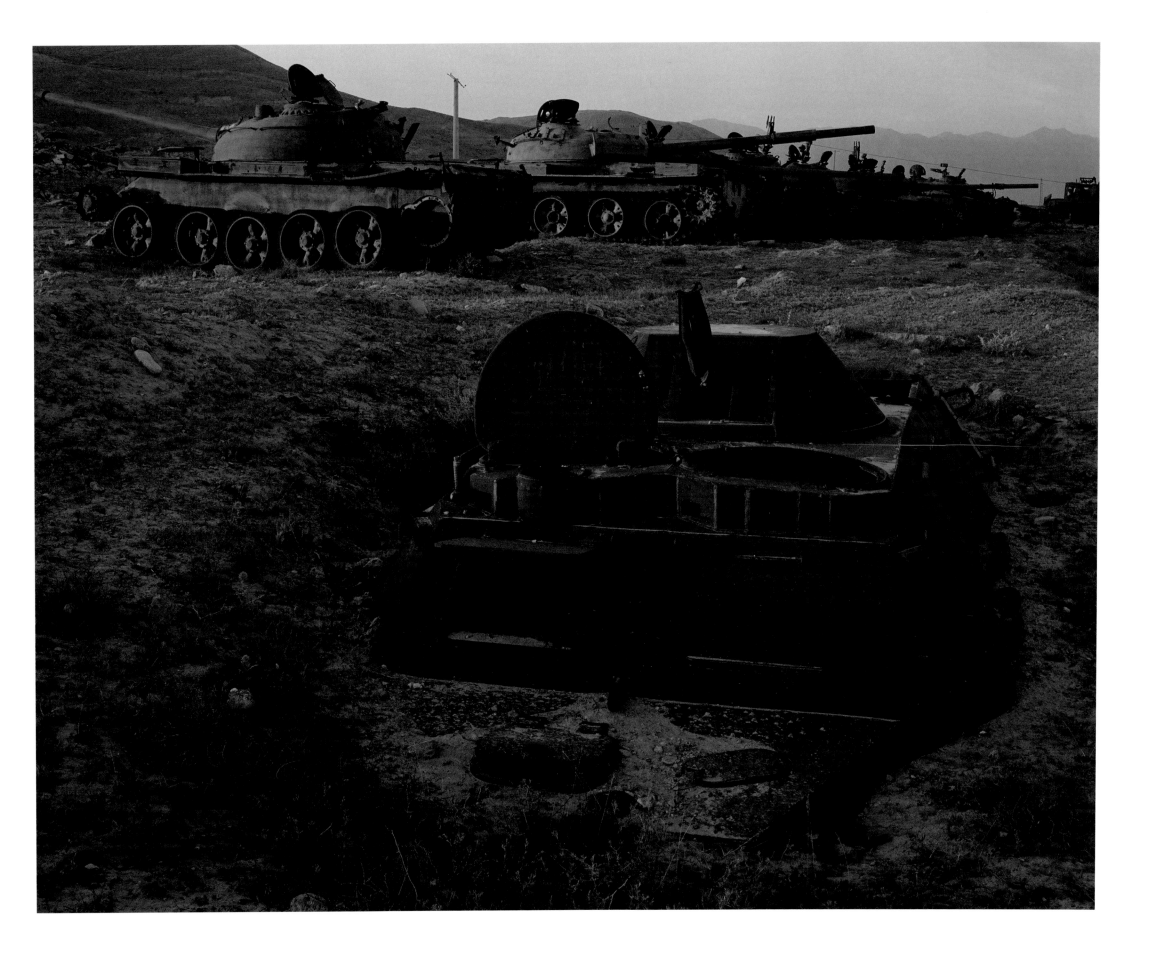

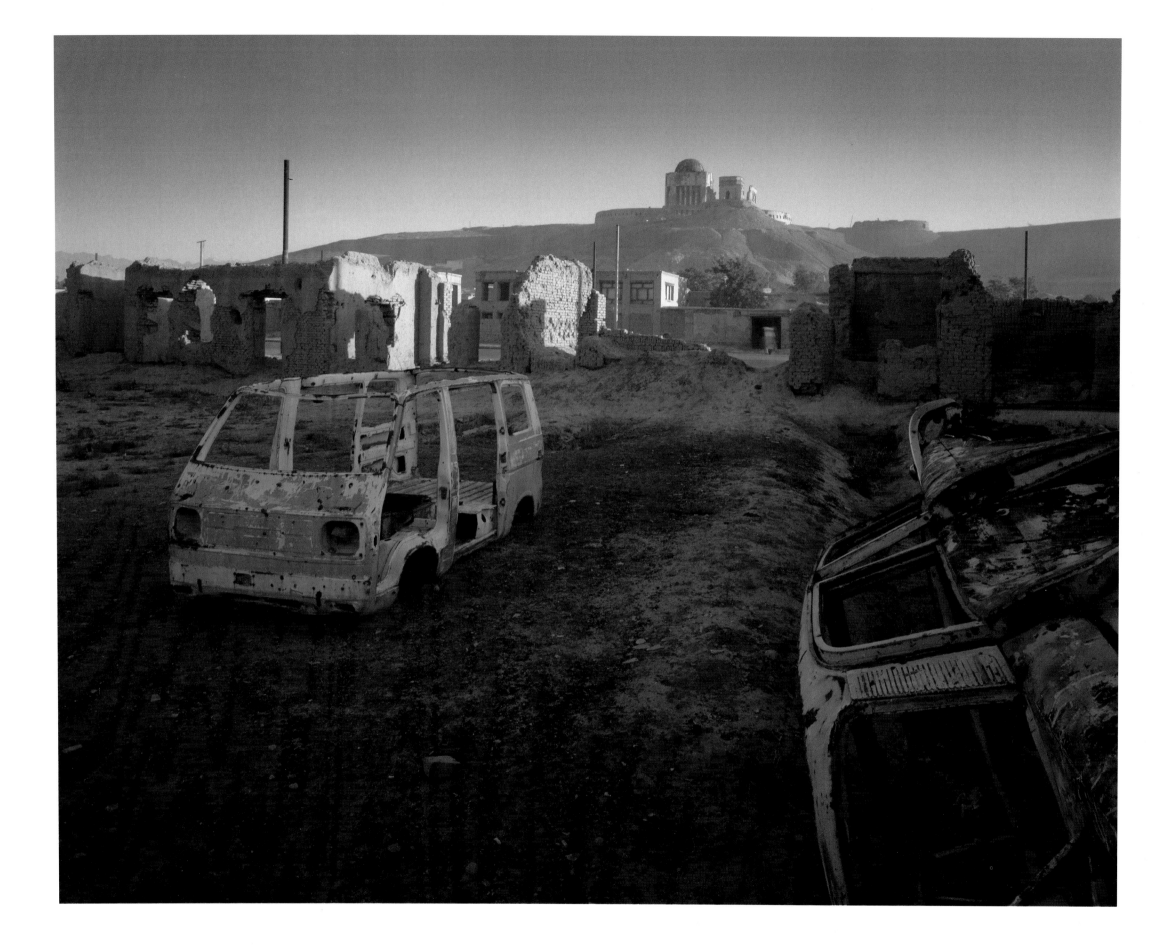

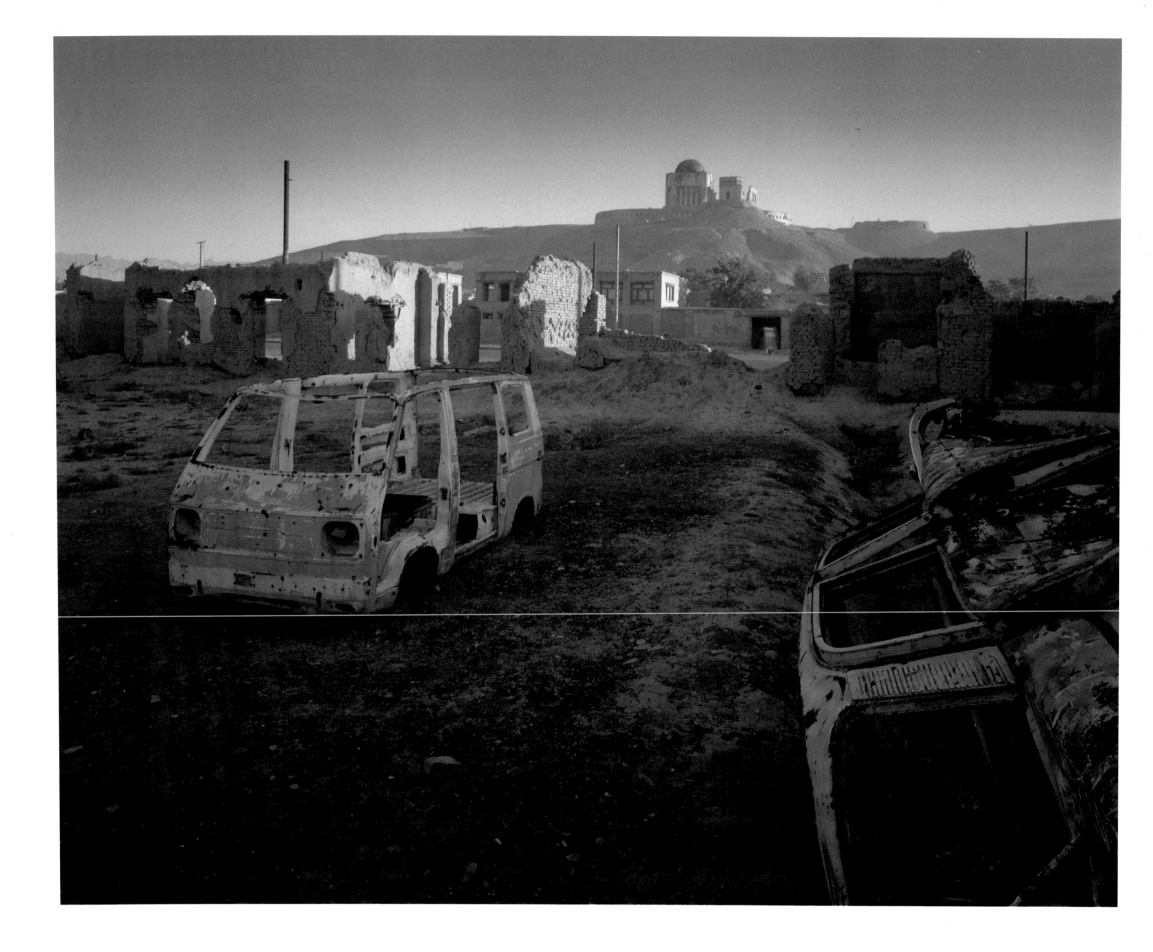

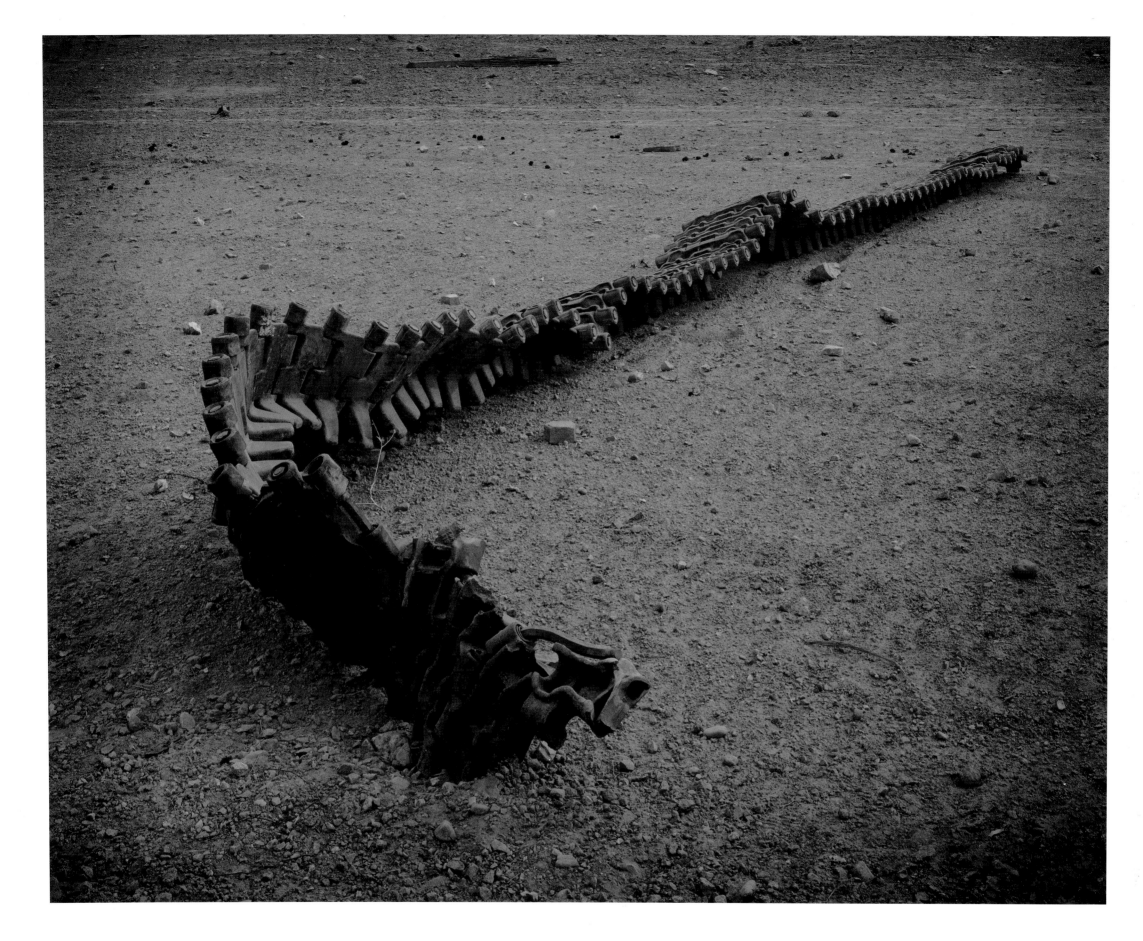

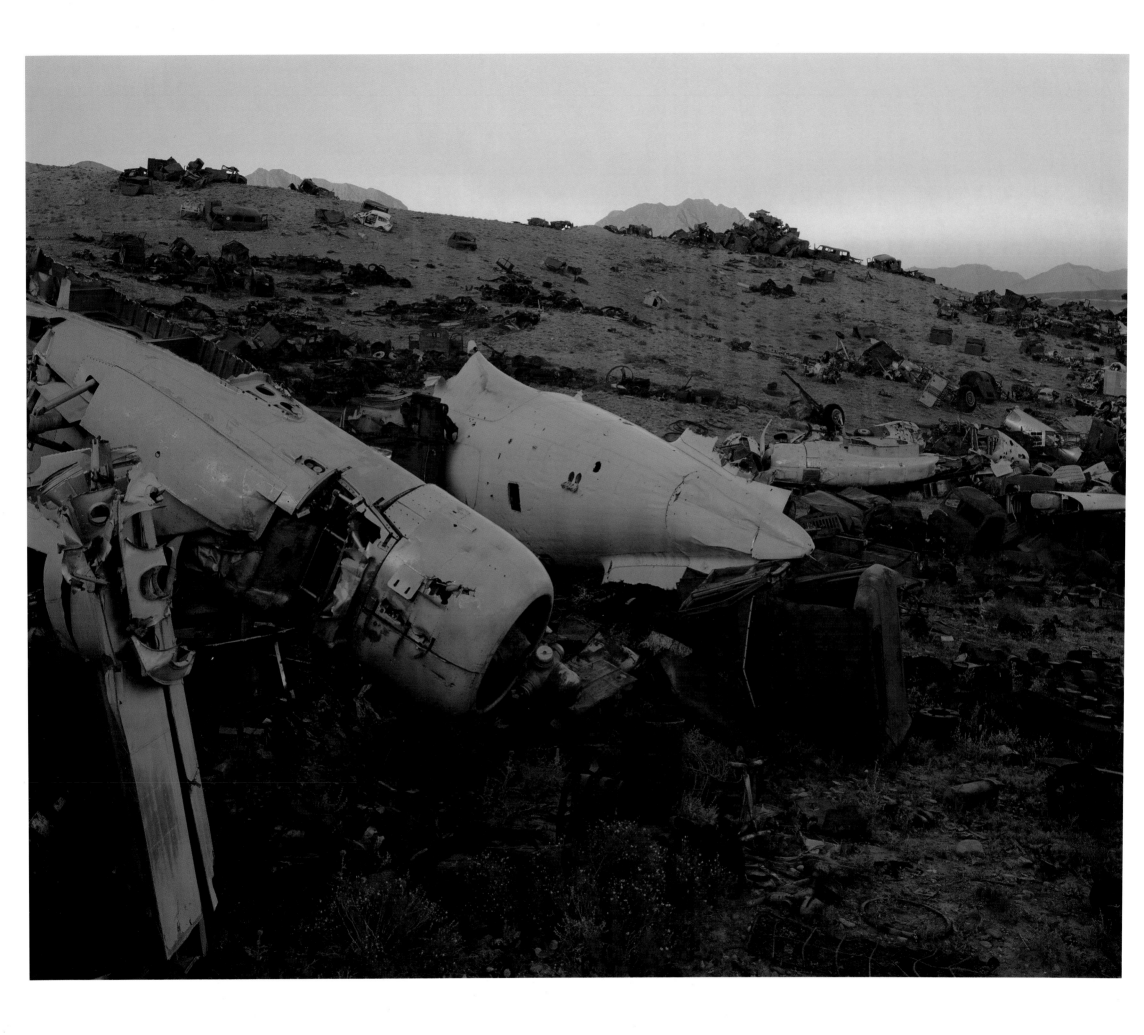

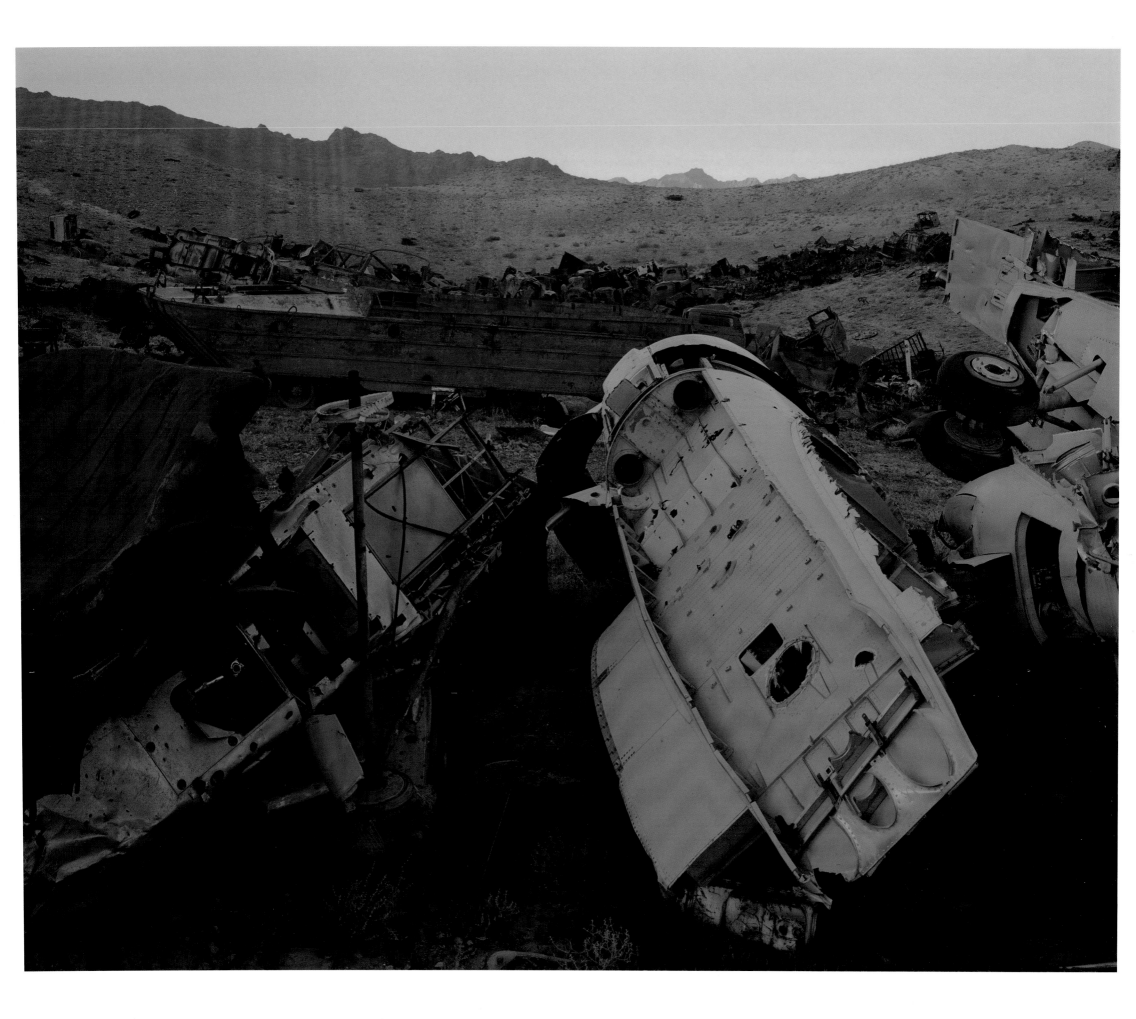

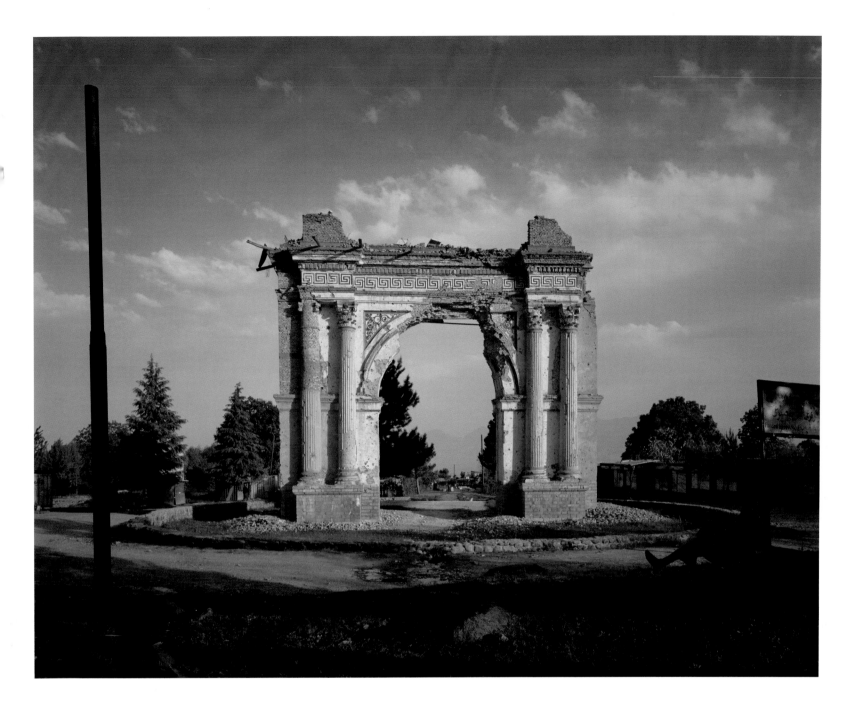

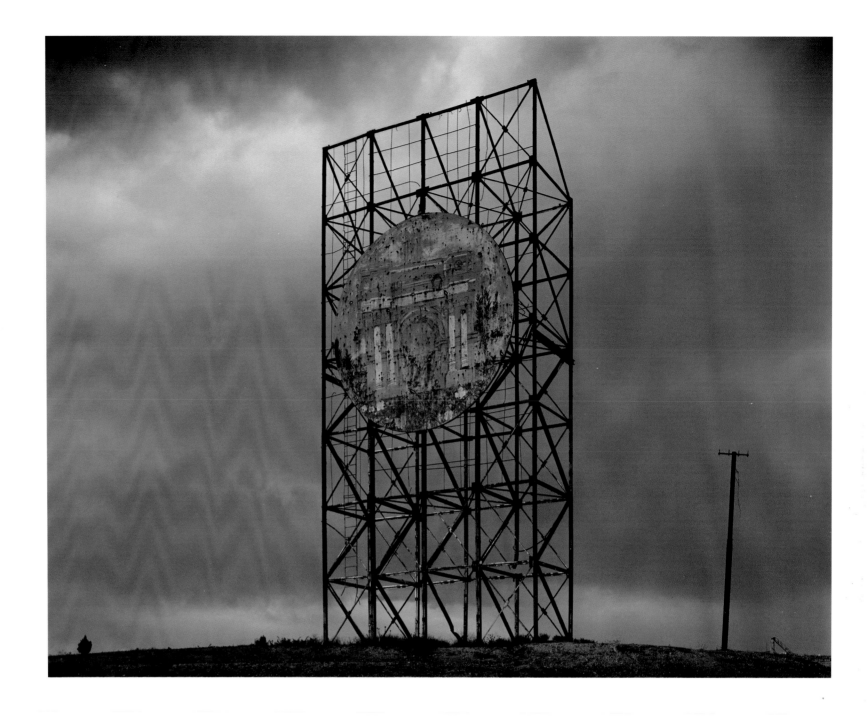

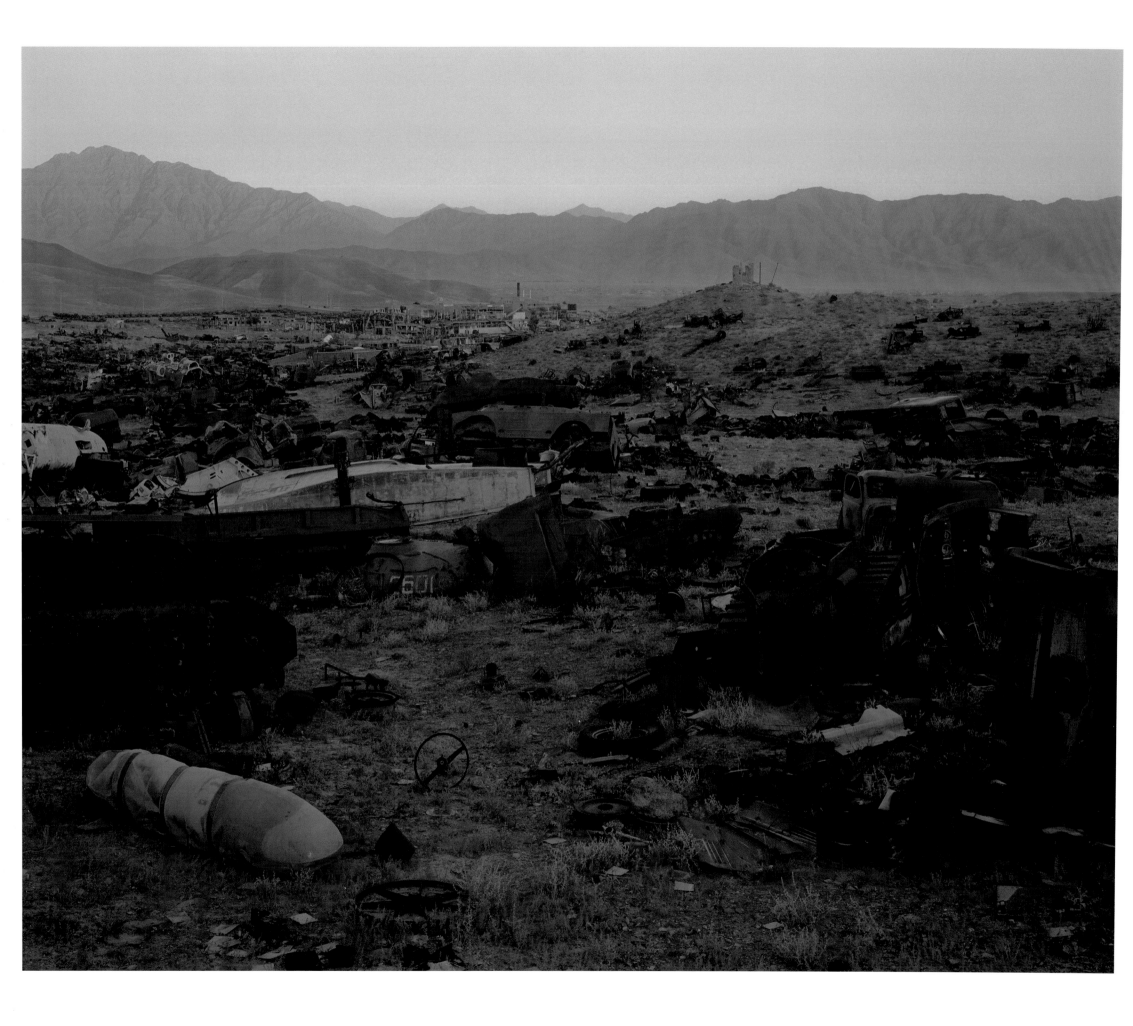

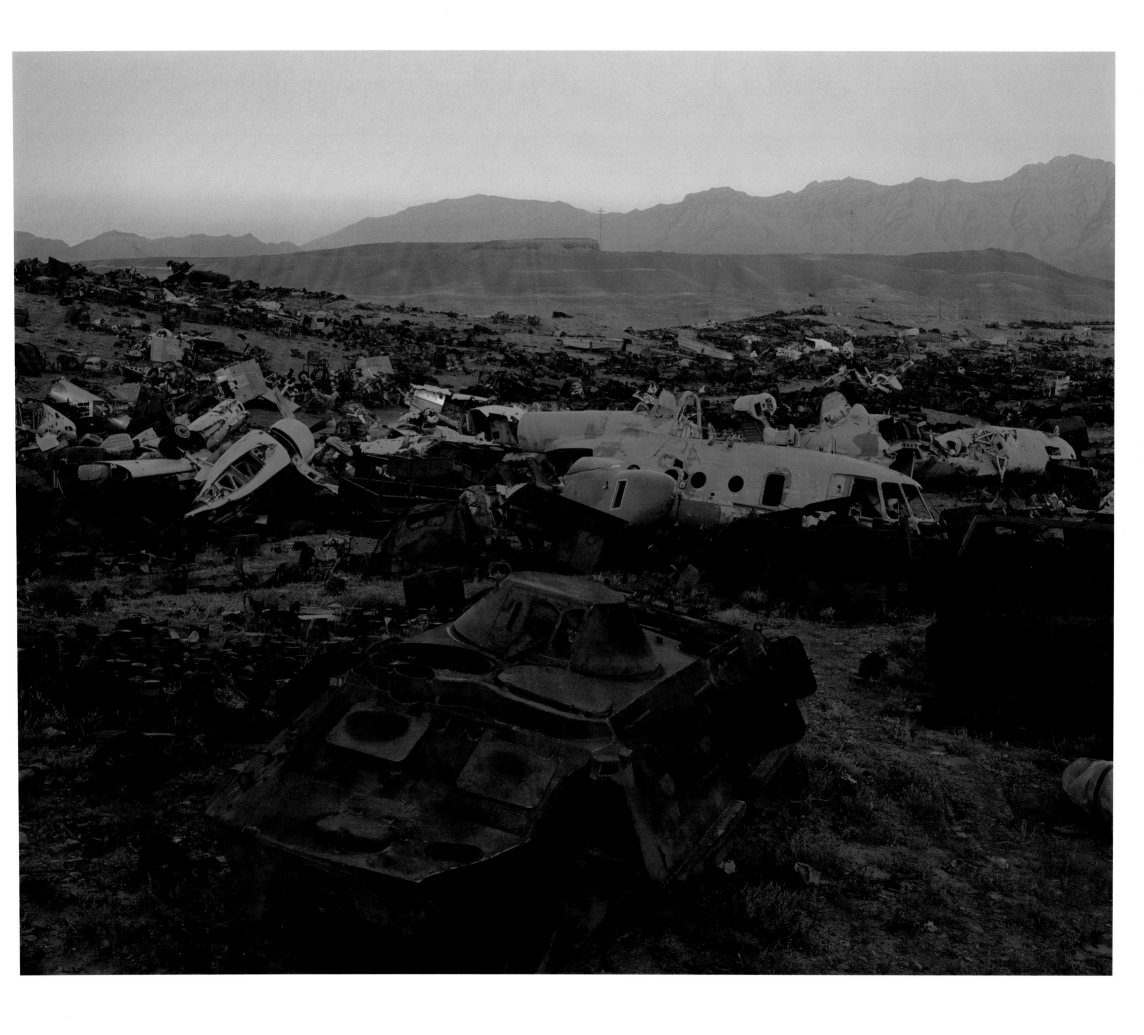

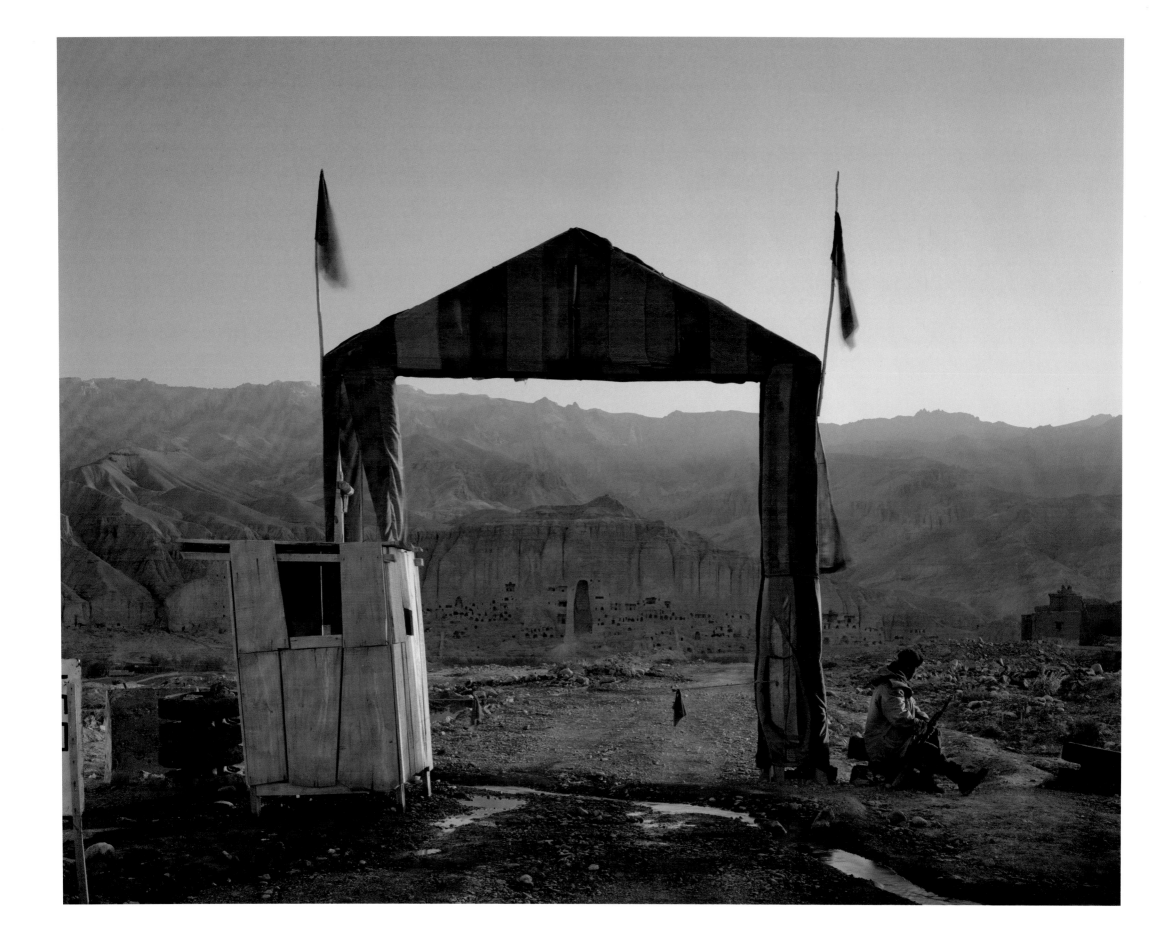

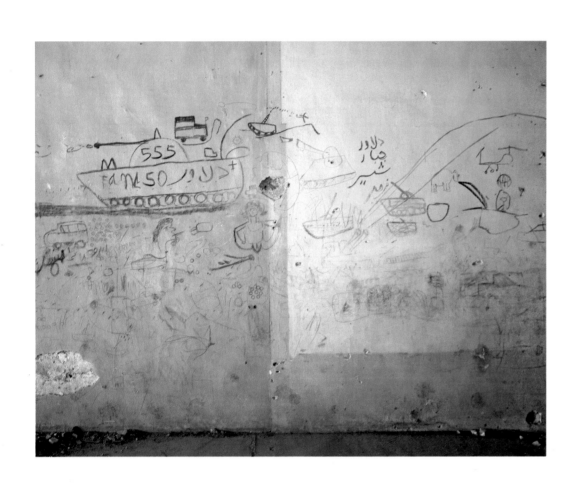

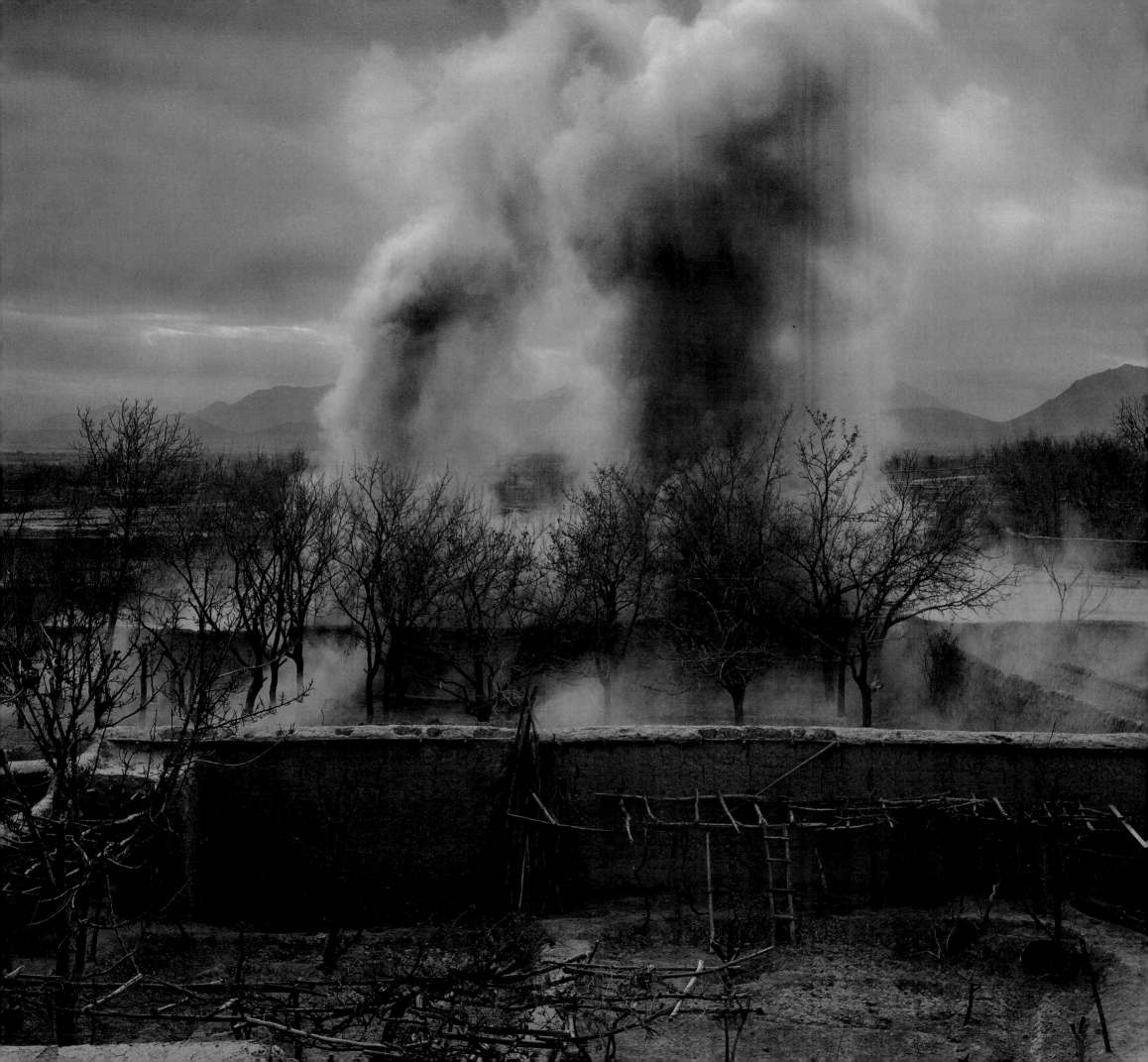

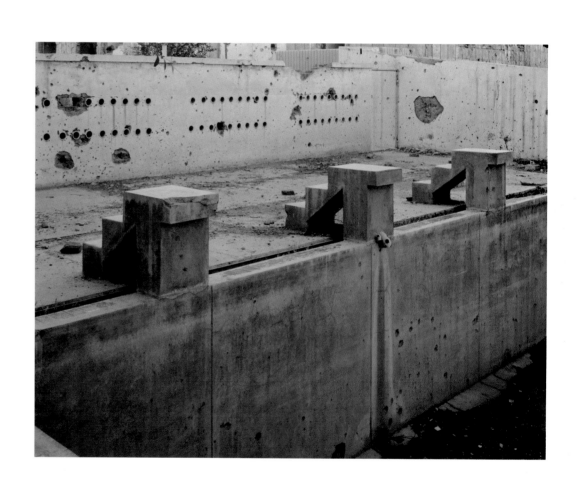

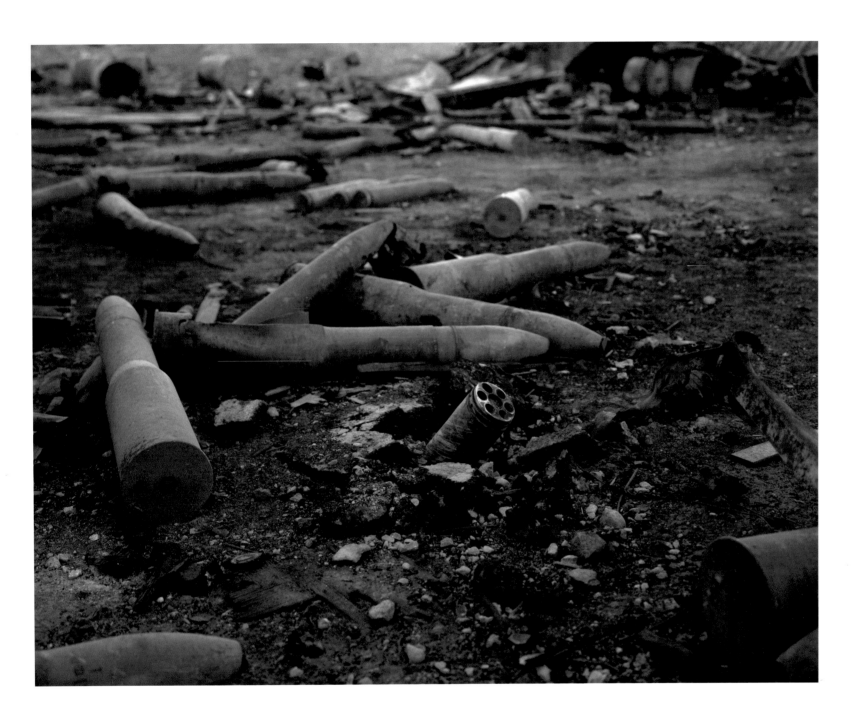

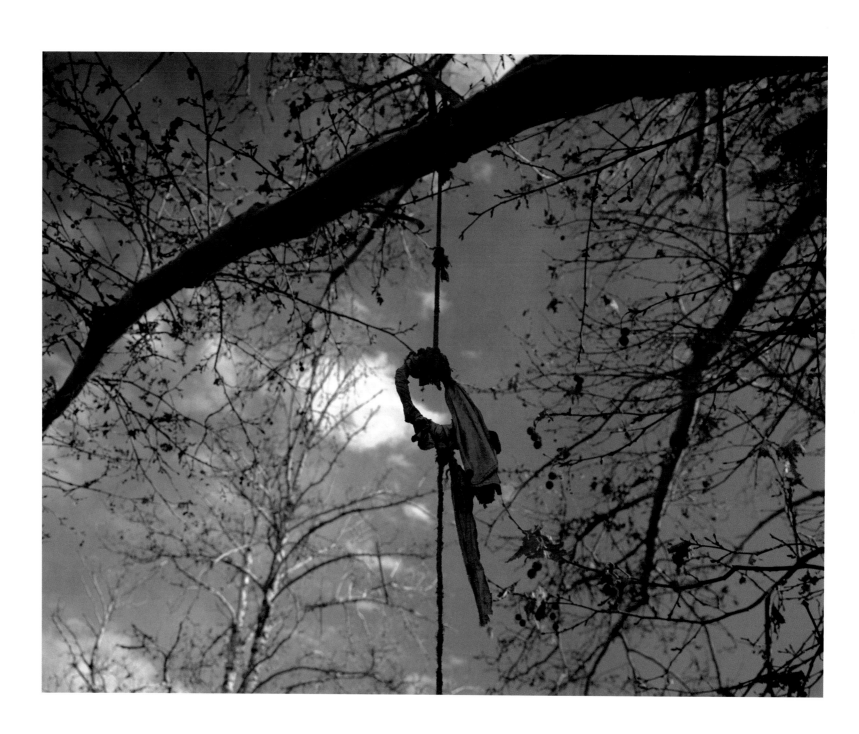

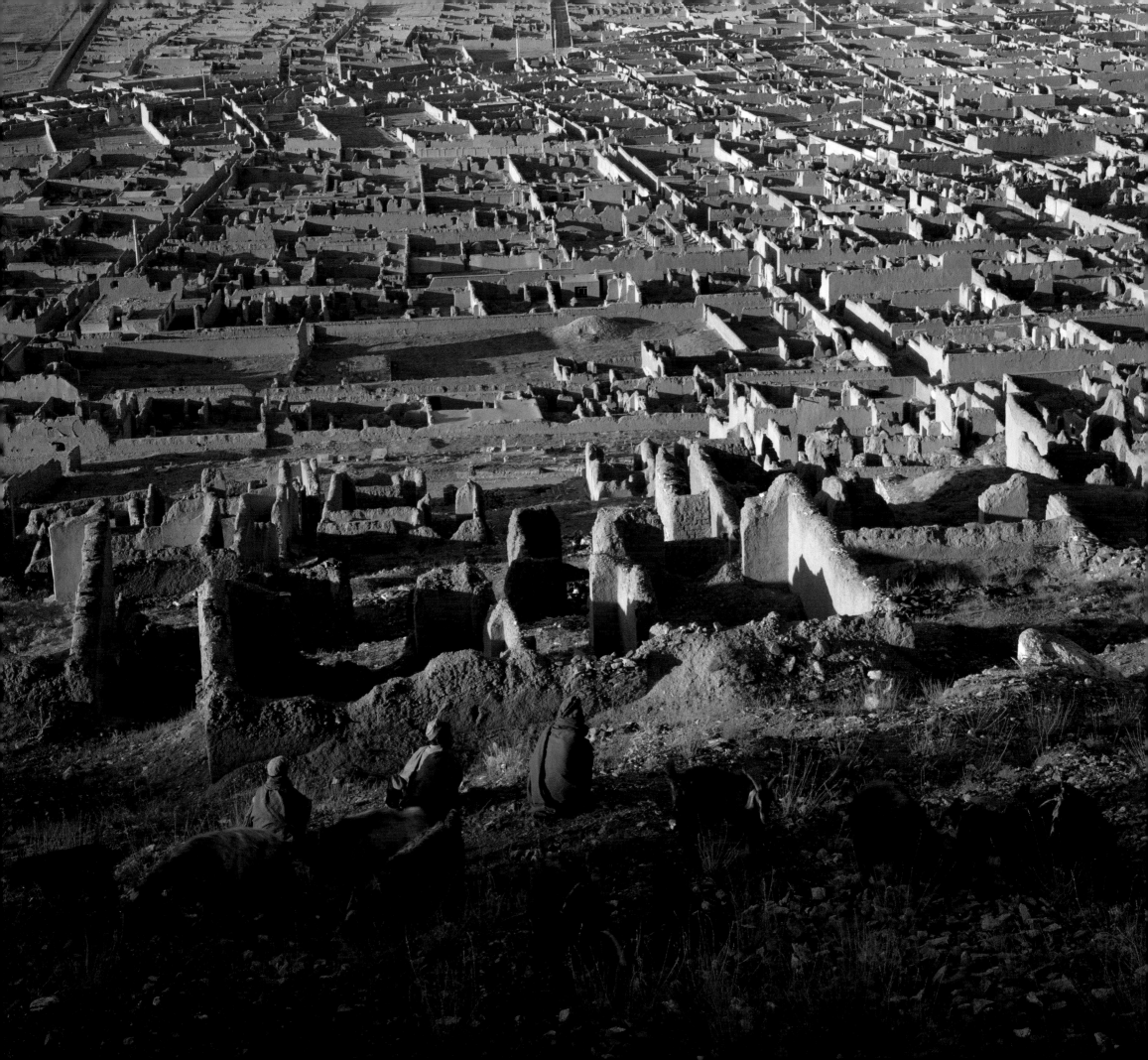

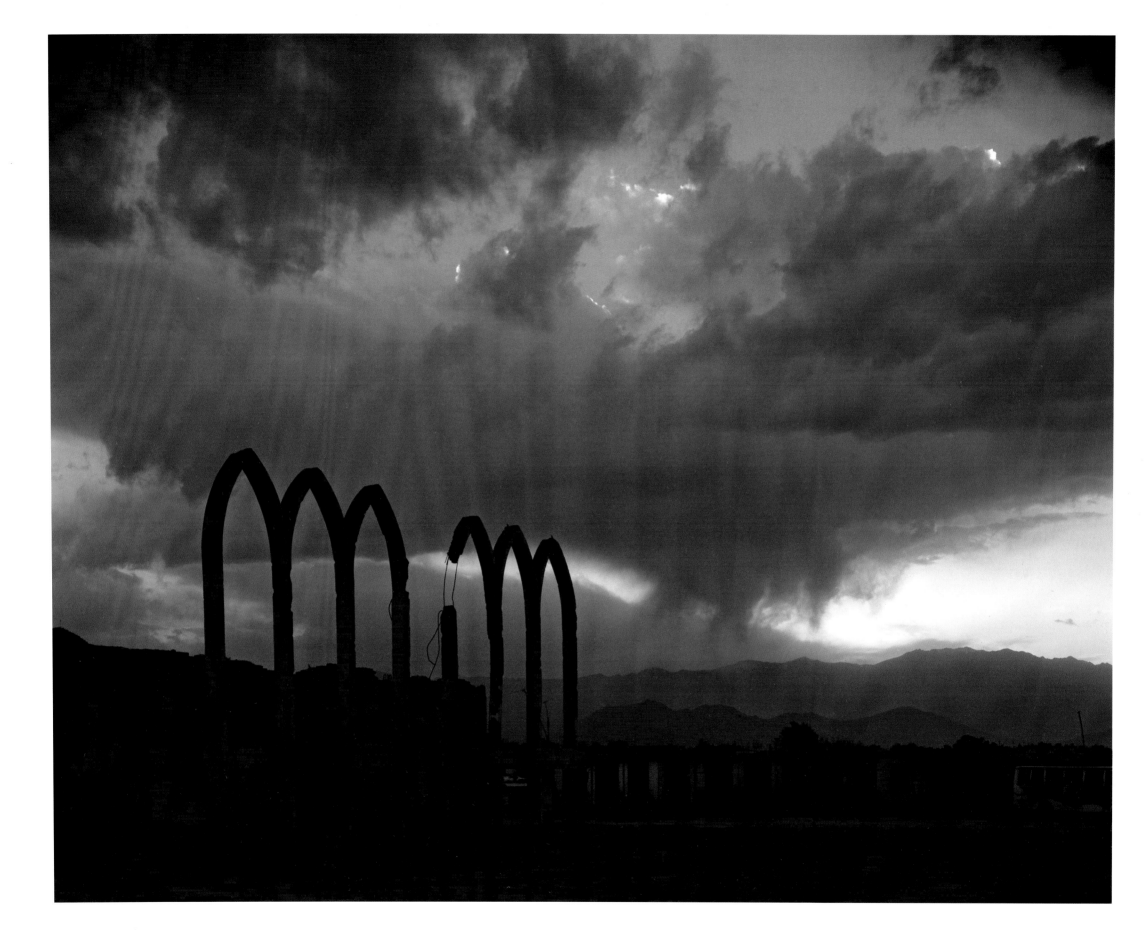

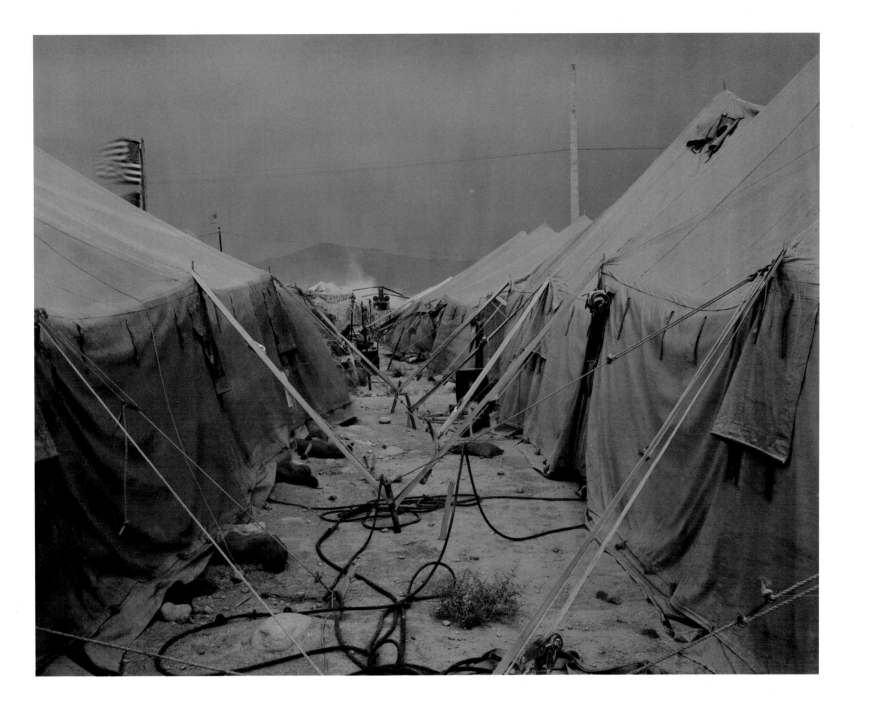

afghanistan
chronotopia

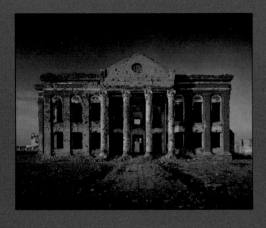

A government building close to the former Presidential palace at Darulaman, destroyed in fighting between Rabbani and the Hazaras in the early 1990s.

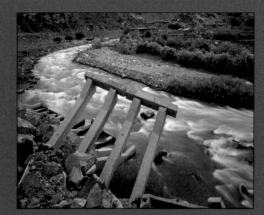

Collapsed avalanche arcading along the road up to the Salang Tunnel. This road through the Hindu Kush was a vital supply line for the warring parties and saw a huge amount of traffic.

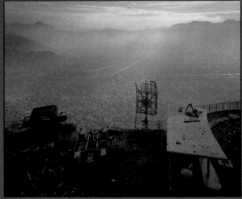

Destroyed military and civilian radio installations on Kohe Asmai (known as 'Radio TV Mountain') in central Kabul. Looking towards the west of the city.

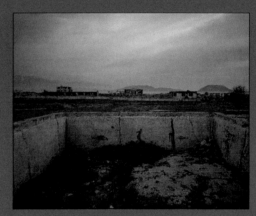

The swimming pool of the destroyed Presidential palace at Darulaman.

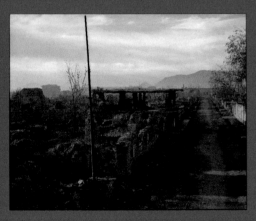

Near Deh Mazang in the Karte Char district of Kabul, the scene of fierce fighting in the early 1990s between rival Mujaheddin factions. Red paint on buildings indicates the presence of unexploded ordnance. The white 'tick' means it has been cleared.

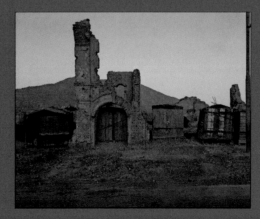

The Chaman, one of Kabul's grandest boulevards, was destroyed during Mujaheddin internecine fighting. Shops in wooden huts have moved into the ruins.

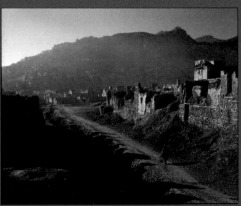

The Shur Bazaar district of Kabul, destroyed by long-range rocket attacks between warring Mujaheddin factions in 1994.

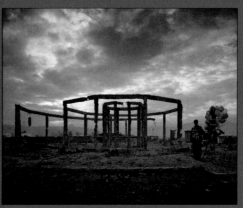

Former teahouse in a park next to the Afghan Exhibition of Economic and Social Achievements in the Shah Shahid district of Kabul. Balloons were illegal under the Taliban, but now balloon-sellers are common on the streets of Kabul providing cheap treats for children.

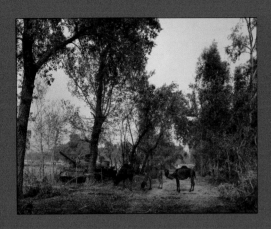

Taliban tanks dispersed under trees to avoid air attack at Farm Hada military base near Jalalabad. The main part of the base was bombed by the Americans destroying some working, and a great many non-working military vehicles and buildings. The site is now being used by local farmers for grazing.

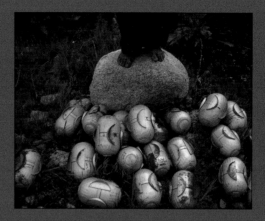

Heavy munitions were brought up to the mouth of the Salang Tunnel by Ahmed Shah Massoud in case he needed to blow the tunnel. These Soviet cluster bombs now lie in the grounds of Olang Elementary School.

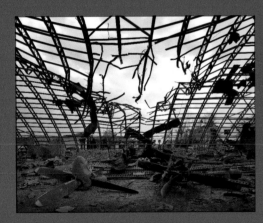

The remains of Antonov cargo planes of the Taliban Air Force at Kabul airport after bombing by the Americans.

The A.T.C. de-mining group marking a minefield at Khayrabad, south of Kabul prior to mine clearing operations. The mines are on the red side; white painted boulders on a hillside indicate cleared areas.

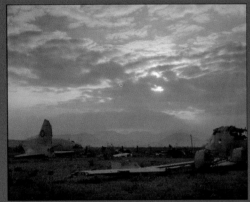

Military hangars containing spares for planes and helicopters at Kabul Airport, destroyed by American bombs.

Rusting anti-aircraft cannon casings on Kohe Asmai (known as 'Radio TV Mountain') in central Kabul.

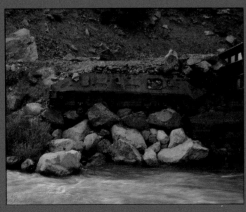

A buried Soviet-era armoured personnel carrier, filled with stones and used as footings for a temporary bridge on the road up to the Salang Pass.

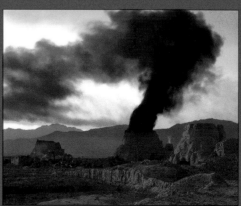

The brickworks at Hussain Khil, east of Kabul. With massive rebuilding taking place in Kabul, the demand for new bricks has soared.

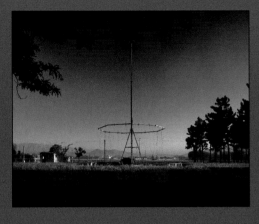

Damaged FM radio antennae at Yachka Tot, eastern Kabul.

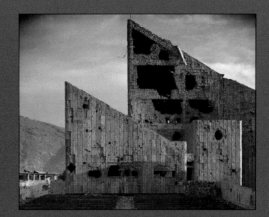

Former Palace of Culture in the Karte Char district of Kabul. The complex housed lecture halls, tennis courts, a swimming pool and a cinema. It is now home to returned refugees.

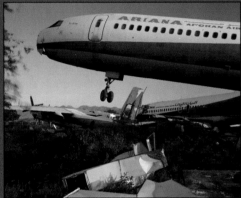

Wrecked Ariana Afghan Airlines jets at Kabul Airport pushed into a mined area at the edge of the apron.

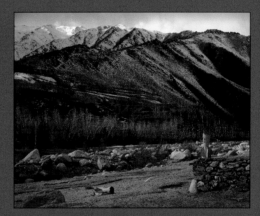

Tail fins of 1980s Soviet aerial bombs (possibly cluster bombs) now in use as field markers. Village of Olang Kalandashah in the Salang Pass.

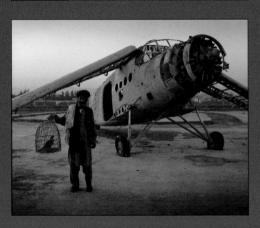

Old biplane on a display plinth at the Exhibition Grounds in Kabul. Fighting birds are a source of great pride to Afghan men, but were banned by the Taliban as un-Islamic.

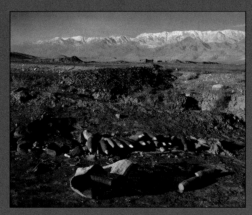

A former Taliban artillery position near Bagram airbase with abandoned 155 mm artillery shells and the bedding and blankets of the killed gun crew.

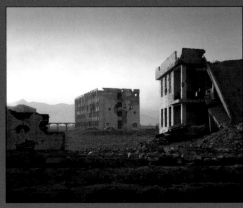

Caretaker in the remains of a military building on Jadayi Darulaman.

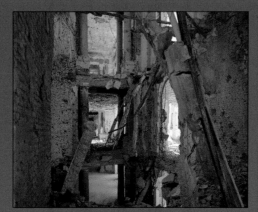

The interior of the utterly destroyed Presidential palace at Darulaman, damaged firstly by the Soviets and later in fighting between Rabbani and the Hazaras in 1992.

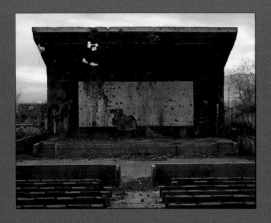

Bullet-scarred outdoor cinema at the Palace of Culture in the Karte Char district of Kabul.

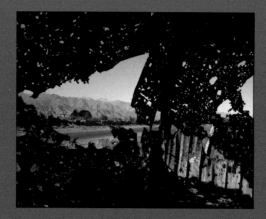

A shipping container used to hide soldiers where they had to move between positions in sight of enemy guns. The frontline passed through this part of the Shomali Plain several times.

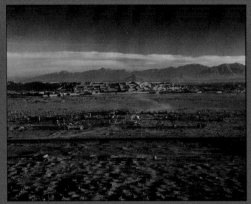

In rocket attacks on Kabul in 1993-4, Gulbuddin Hikmetyar, a former Mujaheddin commander, destroyed the entire Kabul City bus fleet – 4,000 vehicles in total. The carcasses of most of the vehicles were hauled to Gulf Bagrami on the outskirts of Kabul where they have since been cannibalised for spares.

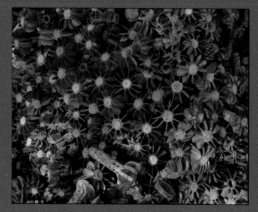

The tail-fins of mortar rounds collected together at the B.A.C. De-mining Centre, Kabul. Four UN de-miners were killed at the centre in a cruise missile attack by the Americans in October 2001.

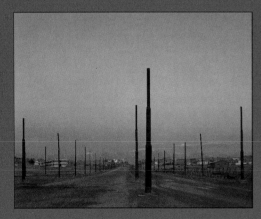

The remains of the trolleybus terminus at Gulf Bagrami.

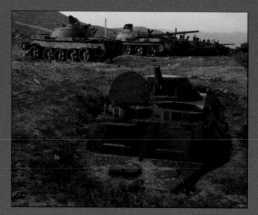

Abandoned tanks and armoured personnel carriers in the desert near Qal-y-Shanan, eastern Kabul.

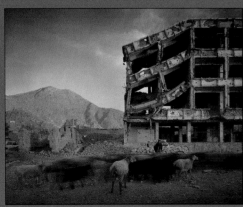

Bullet-scarred apartment building and shops in the Karte Char district of Kabul. This area saw fighting between Hikmetyar and Rabbani and then between Rabbani and the Hazaras.

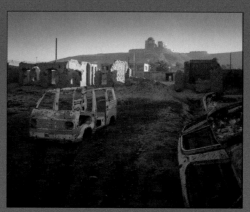

The mausoleum of the dead king, Nadir Shah (d. 1793), Shah Shaheed district, Kabul.

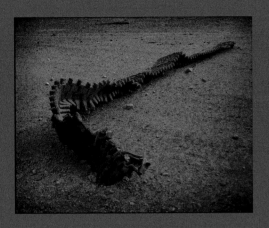

Track of destroyed Taliban tank at Farm Hada military base near Jalalabad.

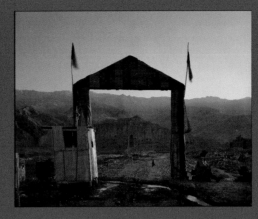

Victory arch built by the Northern Alliance at the entrance to a local commander's HQ in Bamiyan. The empty niche housed the smaller of the two Buddhas destroyed by the Taliban in 2001.

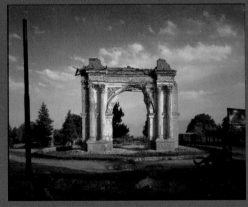

King Amanullah's Victory Arch built to celebrate the 1919 Independence from the British. Paghman, Kabul Province.

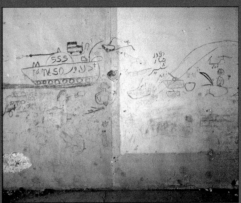

Graffiti on the walls of the National Theatre, used as a billet for the army of General Rashid Dostum during power struggles for Kabul in the early 1990s.

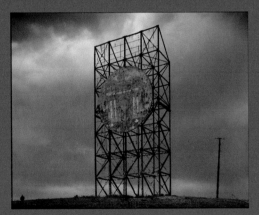

Hoarding above the Exhibition Grounds showing the Paghman Victory Arch, central Kabul.

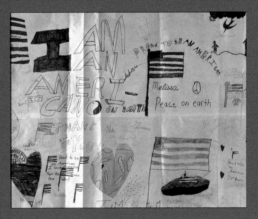

Mural made by American schoolchildren, hanging in the mess tent at the US military base at Bagram.

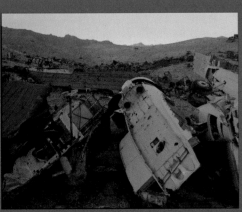

A vast amount of unrepairable military equipment has been dumped in the desert behind the Military Technical Academy at Qal-y-Shanan on the eastern outskirts of Kabul.

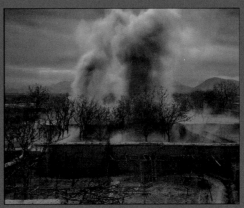

Controlled destruction by the Halo Trust of US cluster bombs dropped in error on the civilian village and orchards of Aqa Ali-Khuja, Shomali Plain north of Kabul.

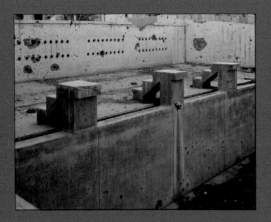

The swimming pool of the former Palace of Culture, Karte Char district, Kabul.

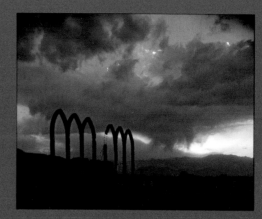

The old terminal for Jalalabad-Kabul buses.

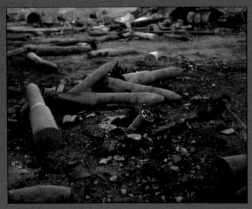

BM-12 rocket fired from its tube and driven into the ground without exploding. At the Khar Khana Barracks in Kabul, devastated by American B-52 attacks.

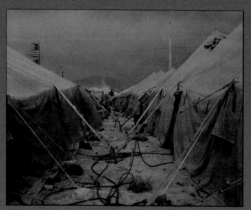

'Viper City', the encampment of the 101st Airborne Division of the American Army at Bagram airbase.

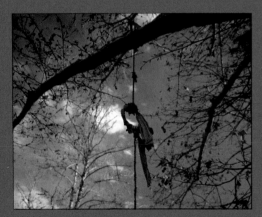

Noose hanging from a tree in Rishkor Al-Qaeda camp used for punishment beatings. It is, reportedly, the noose from which the Taliban hung the American sponsored opposition leader Abdul Haq.

American bombers searching for and attacking Al-Qaeda targets in Tora Bora; seen from the outskirts of Kabul.

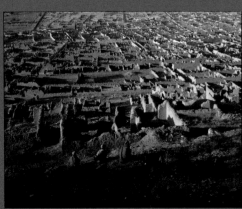

The district of Afshar in western Kabul. This Hazara neighbourhood was completely devastated during ethnic fighting between the residents and Rabbani's forces in the early 1990s.

chronology

Darius I of Persia and Alexander the Great were the first to invade Afghanistan, using the country as a gateway to India. They were followed in the 7th century by Islamic conquerors and, in the 13th and 14th centuries, by Genghis Khan and Tamerlane. All these empire builders left their mark.

Around 1750, Ahmad Shah Duranni brought together a state recognisable as the precursor to Afghanistan. A high-point in Afghan history, his control stretched from central Asia to Delhi and from Kashmir to the Arabian Sea.

In the 19th century, Afghanistan became a battleground in the rivalry between Imperial Britain and Czarist Russia for control of Central Asia. Three Anglo-Afghan Wars (1839-42, 1878-80, and 1919) ended inconclusively, with full independence from Britain achieved only in 1919.

During the Cold War, King Mohammed Zahir Shah developed close ties with the Soviet Union, accepting extensive economic assistance from Moscow. His overthrow in 1973 was followed by a decade of instability as liberal reformists came under pressure from both radical Marxists seeking closer ties with Moscow; and from Washington-supported, armed conservatives who sought to create an Islamic state. Fearing the government was on the verge of collapse, Moscow responded with a full-scale invasion of the country in December 1979.

The Soviets were met with fierce resistance from Mujaheddin groups already invigorated by opposition to the liberal government. Initially independent and armed with outdated weapons, they soon became caught up in Cold War superpower rivalry. Washington began secretly funnelling billions of dollars of sophisticated weaponry into Afghanistan, with the CIA taking the lead in training and funding. Iran, China, Pakistan and Saudi Arabia, who all wished to see a weakened USSR, supplied additional military assistance.

Moscow's troops were soon bogged down in a brutal, unwinnable conflict and eventually, worn out and beaten, they sued for peace. The Soviet withdrawal was completed in February 1989, leaving the pro-Soviet government of President Najibullah in precarious control of Kabul.

The cost of this decade of fighting is hard to calculate. Perhaps one million Afghans lost their lives and up to 5,000,000 were made refugees in a proxy war, fought at arms length, between the USSR and the USA. Many have argued that in funding and training the opposition to the Soviets, the CIA created the radical Islamists who were later to become the terrorists of September 11th.

When the Mujaheddin finally captured Kabul in April 1992, fighting continued unabated as the commanders of the various factions vied for control. Anarchy ensued; tens of thousands were killed; Kabul was devastated in repeated and often random rocket attacks; and whole districts of the city were ethnically cleansed.

From murky beginnings in 1994, instigated and controlled by Pakistani Intelligence and financed by Saudi Arabia, a group calling itself the Taliban emerged as an alternative to self-serving, Mujaheddin in-fighting. Initially popular, they swept to military victories across Afghanistan finally seizing control of Kabul in September 1996. By late 1998, the Taliban controlled some 90% of the country, with Ahmed Shah Massoud's opposition confined to a mountainous corner of the North East.

The Taliban's scorched-earth tactics, human rights abuses and ultra-hardline interpretation of Islam isolated them from the international community and oppressed ordinary Afghans. In March 2001, despite worldwide protests, the Taliban destroyed the magnificent Buddhist statues at Bamiyan, dating from the second and fifth centuries. Furthermore, the Taliban were suspected of allowing foreign terrorist organisations to run training camps in their territory. On August 20th 1998, U.S. cruise missiles struck an Al-Qaeda training complex near the eastern town of Khost in an attempt to kill Osama Bin Laden, believed to be involved in the bombing of the American embassies in Kenya and Tanzania. After the catastrophic attacks on the World Trade Centre and the Pentagon on September 11th 2001, Bin Laden was named chief suspect and the Taliban were accused of harbouring wanted criminals.

On October 7th, after the Taliban repeatedly refused to turn over Bin Laden, the USA (supported by the British) began air strikes in revenge for the attacks on Sept. 11th. There followed five weeks of ferocious aerial bombardment involving everything from precision-guided weapons to cluster bombs, B-52 carpet bombings and BLU-82 Daisy Cutters. When the American attacks were over, the Northern Alliance walked into Kabul to find virtually no resistance. On December 7th, the Taliban regime collapsed entirely when its troops fled their last stronghold in Kandahar, although skirmishes continue in the mountainous east of the country.

Although there is the possibility of real democracy emerging under the new government of Hamid Karzai, it has come at a terrible price. Thousands died in the American bombardment and Afghanistan's tattered infrastructure, wrecked by decades of war, is now utterly devastated. Taliban leader Mullah Omar as well as Osama Bin Laden remain at large.

S. N.

London
July 2002

European Publishers Award
for Photography 2002
Ninth edition

Jury

Jean-Paul Capitani
Actes Sud

Dewi Lewis
Dewi Lewis Publishing

Günter Braus
Edition Braus

Andrès Gamboa
Lunwerg Editores

Mario Peliti
Peliti Associati

Paul Mellor
Open Eye Gallery

Gero Furchheim
Leica Camera AG

Copyright © 2002

For the photographs and text
Simon Norfolk

For this edition
Actes Sud (France)
Dewi Lewis Publishing (United Kingdom)
Edition Braus (Germany)
Lunwerg Editores (Spain)
Peliti Associati (Italy)

Design
Jonathan Towell
07958 638 466

Production
Dewi Lewis Publishing

Print
EBS, Verona

All rights reserved
ISBN: 1-899235-54-X

Dewi Lewis Publishing
8 Broomfield Road
Heaton Moor
Stockport SK4 4ND
England

www.dewilewispublishing.com

For further information on Simon Norfolk
www.growbag.com

Simon Norfolk would like to thank:

Translators
Dorothee Gillessen
Antonio Humberto Zazueta Olmos
Carole Patton

Jonathan Towell
Dewi Lewis and Caroline Warhurst
Kathy Ryan
Shirley Read
Specialist Jeremy Guthrie
Harriet Logan
Jenny Matthews
Regina Rylanda
Fl. Lt. Jol Fall
Steven Robert Coleman
Paul Lowe
Brett Rogers and staff at the British Council
The staff and photographers at Growbag
Vance Gellert
Nirupama Sekhri

DEWI LEWIS
PUBLISHING